Ellen H. Johnson is Professor of Art at Oberlin College, Ohio, U.S.A. She has also been visiting professor in Scandinavian art at the University of Wisconsin and visiting lecturer in post-war American art at Uppsala University. In 1968 she was United States Commissioner at the New Delhi Triennale of Contemporary Art. She has written extensively on contemporary art in American and European magazines and in exhibition catalogues, and has published several Oldenburg studies including the first monographic article in *Art International,* January 1963. She has organized several of the Three Young Americans exhibitions at Oberlin, where some of the most important American artists have been shown early in their careers, including Oldenburg. While she has mainly concentrated on contemporary art, she has also written on earlier artists, including Fragonard, Cézanne, and Picasso.

Claes Oldenburg

by Ellen H. Johnson

Penguin Books Ltd, Harmondsworth, Middlesex, England
Penguin Books Inc., 7110 Ambassador Road, Baltimore,
Maryland 21207, U.S.A.
Penguin Books Australia Ltd, Ringwood, Victoria, Australia

First published by Penguin Books 1971
Copyright © Ellen H. Johnson, 1971
Designed by Gerald Cinamon
Manufactured in the United States of America

Library of Congress Catalog Card number 70–139845

In memory of my parents

Claes Thure Oldenburg:

1929	Born in Sweden
1936—56	Resident in Chicago
1945—50	Studied at Yale University, B.A. degree in English literature and art
1956	Moved to New York
1963	Moved to Venice, California
1964	Returned to New York; April to November in Europe
1966	August to October in Stockholm
	October to November in London
1968—70	Frequently in Los Angeles (numerous Gemini projects)
	Several trips to Europe (installing exhibitions, preparing publications, lecturing, etc.)

Selected one-man exhibitions and happenings

1959	Cooper Union Art School Library, New York (drawings)
	Judson Gallery, New York (constructions with drawings and poems—*Duckwalker, Elephant Mask.* etc.)
1960	*Snapshots from the City* happening, in 'Ray Gun Spex', Judson Gallery, New York
	Second show on *Street* theme, Reuben Gallery, New York
1961	*Ironworks, Fotodeath (Circus)* happenings, Reuben Gallery, New York
1962	Ray Gun Theater, New York (five happenings, each in two very different versions)
	Dallas Museum of Contemporary Art (selections from the *Store,* and *Injun* happening)
	Pat's Birthday, film with Robert Breer
	Green Gallery, New York — third version of the *Store* (including large sewn sculptures)
1963	Richard Feigen Gallery, Chicago (and *Gayety* happening, University of Chicago)
	Dwan Gallery, Los Angeles *(Soft Telephone, Soft Typewriter,* etc.)
	Autobodys happening, Los Angeles
1964	Sidney Janis Gallery, New York (*Home* theme)
	Ileana Sonnabend Gallery, Paris
1965	*Washes* and *Moviehouse* happenings, New York
1966	Sidney Janis Gallery, New York (*Bathroom* and *Airflow*)
	Moderna Museet, Stockholm
	Robert Fraser Gallery, London
1967	Sidney Janis Gallery, New York *(Drainpipes, Giant Fagends Soft Fan—Ghost Version)*
	Museum of Contemporary Art, Chicago (monument proposals)
1968	Irving Blum Gallery, Los Angeles
1969	Richard Feigen Gallery, Chicago ('feasible' monuments — models and drawings)
	Museum of Modern Art, New York (retrospective exhibition)

| 1970 | Retrospective exhibition at Stedelijk Museum, Amsterdam; Städtische Kunsthalle, Düsseldorf; Tate Gallery, London Sidney Janis Gallery *(3-way Plugs, Typewriter Eraser,* etc.) |

Selected group exhibitions

1958	Red Grooms's City Gallery, New York (drawings)
1959	With Jim Dine at Judson Gallery, New York *(Street Head I, Celine Backwards,* etc.)
	'Below Zero', Reuben Gallery, New York *(Empire 'Papa' Ray Gun,* etc.)
1960	*The Street* environment in 'Ray Gun' show (with Jim Dine), Judson Gallery, New York
	'New Forms — New Media' (I and II), Martha Jackson Gallery, New York (designed poster, used as catalog cover)
1961	'Environments, Situations, Spaces', Martha Jackson Gallery, New York (first version of *The Store* — mostly reliefs)
	Green Gallery, New York (designed poster)
1962	'New Realists', Sidney Janis Gallery, New York *(Lingerie Counter,* etc.)
1963	'Three Young Americans', Oberlin College, Ohio
	'Popular Image', Washington Gallery of Modern Art (and *Stars* happening)
	'Americans 1963', Museum of Modern Art, New York
1964	'Four Environments', Sidney Janis Gallery, New York *(Bedroom Ensemble)*
	XXXII Biennale, Venice
1965	'Recent Work . . .', Sidney Janis Gallery, New York (colossal monuments drawings, etc.)
1967	'Dine, Oldenburg, Segal', Art Gallery of Ontario, Toronto and Albright-Knox Gallery, Buffalo
	IX Bienal, São Paulo (Bedroom Ensemble)
	'Guggenheim International Exhibition', New York *(Giant Soft Drum Set)*
	'Sculpture in Environment', New York Parks Commission, *Hole* dug in Central Park
1969	'An Exhibition by Seven Artists', Sidney Janis Gallery, New York (models for *Icebag* and *Lipstick* monuments)
	'Pop Art', Hayward Gallery, London *(Bedroom Replica)*
1970	'New Arts', American Pavilion, Expo '70, Osaka

Acknowledgements

For their friendly assistance, I should like to thank the following: Miss Alicia Legg and Miss Helen Franc, both of the Museum of Modern Art, New York, the staffs of the Sidney Janis Gallery and the Richard Feigen Gallery, Mr and Mrs Gösta Oldenburg, and Mrs Pat Oldenburg. The publishers and I gratefully acknowledge the kindness of the museums and individuals who have given permission to reproduce works in their collections. My sincere thanks are extended to Mrs Ruth C. Roush and to Oberlin College for grants in aid of research. I am especially indebted to Mrs Athena T. Spear for her valuable suggestions throughout all phases of the work and to Mrs Chloe H. Young for reading and criticizing the manuscript. Above all, I wish to thank Claes Oldenburg for his extraordinary generosity and tolerance over the years.

Ellen H. Johnson
Oberlin, Spring 1970

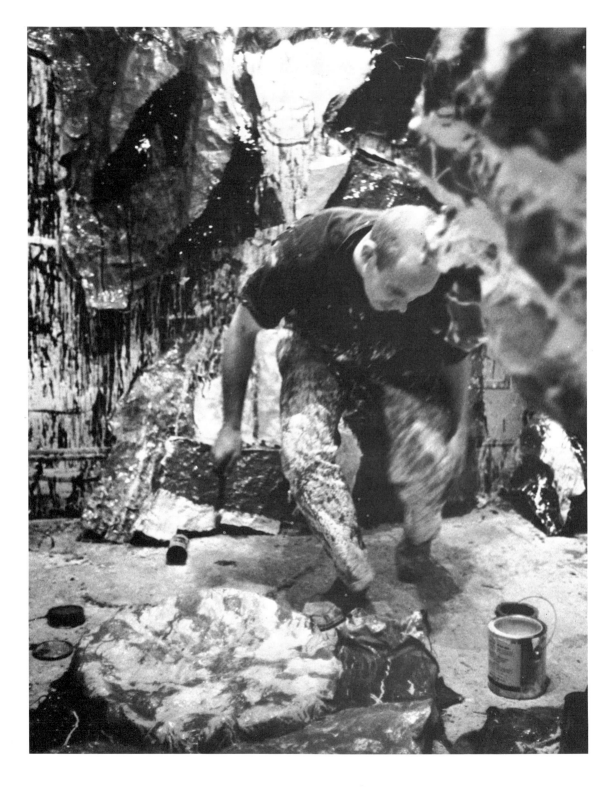

Claes Oldenburg arrived in New York on 1 June 1956, the summer of Jackson Pollock's death. The golden age of abstract expressionism was over. Although a few of the original masters of that movement still continue to produce works of great beauty and significance, by 1956 its revolutionary force had become blunted by excessive and superficial imitation. There were, however, several inventive young artists who had dared to question some of their elders' premises at the same time that they built upon them and, from their predecessors' example, gained courage to make their own forays into new territory. By the mid fifties, Robert Rauschenberg had constructed numerous 'combines' of paint and such unlikely objects as a parasol, grass, bed quilt and a chicken, and he had made a *Dirt Painting*; Jasper Johns had painted his ground-breaking flags and targets; Helen Frankenthaler, and subsequently Morris Louis, had made pictures by tilting canvas and letting paint roll over and stain it; John Cage had given his first 'simultaneous presentation of unrelated events'; under his influence, Allan Kaprow was soon to present his first happening; and Claes Oldenburg had only just begun to think of himself as a visual artist. However, within a very few years, Oldenburg was to thrust his independence as far afield from Pollock, while still remaining his direct inheritor, as any of the others had done. In the notes written while he was working on his *Store* exhibition, Oldenburg pungently expressed his relationship to his predecessor, 'Lately I have begun to understand action painting that old thing in a new vital and peculiar sense – as corny as the scratches on a New York wall and by parodying its corn I have (miracle) come back to its authenticity! I feel as if Pollock is sitting on my shoulder or rather crouching in my pants!'[1] In a photograph taken at that time [1], Oldenburg is seen throwing his whole body into the act of painting as passionately as ever Pollock did.

The ambivalence of Oldenburg's attitude towards his immediate precursor is part of his attitude toward tradition in general: he revolts against it, at the same time that he cherishes and renews it. This is true not only of his aesthetic, but of his social and cultural heritage as well. He comes from the Swedish higher bourgeoisie with its pronounced respect for tradition and formalism. Claes Thure Oldenburg was born in Sweden in 1929; his father being in the Swedish foreign service, the family moved about a good deal in the early years between Sweden, the States and Norway, before settling in Chicago in the fall of 1936. Here Claes grew up in an urbane milieu. His mother has the disposition toward mysticism popularly associated with the North,

1. Oldenburg painting *The Store* reliefs, 1961

while his father is more cooly intellectual and precise, as well as inventive. Oldenburg respects his father's neatness of mind, but opposes it in the prodigal spilling-over of his productivity, and in its open, unfixed character which conceals the disciplined work and thought that have gone into it. He gently ridicules his mother's predilection for mystic doctrines (Swedenborgianism, spiritualism, metempsychosis), but his own thinking is centered in his irrational being. He writes, 'I know that down to the last simple detail experience is totally mysterious . . . what I want to do more than anything is to create things just as mysterious as nature',[2] and 'Mystery or not knowing interests me more than knowing'.[3] About his contribution to the 'Art by Telephone' exhibition at the Chicago Museum of Contemporary Art in 1969, for which he telephoned each day messages to be posted on a blackboard, Oldenburg remarked, 'One thing I wanted to get in is the idea of seances and spirit writing'.[4] He dwells among his fantasies and dreams, deliberately cultivating them; and he records and analyzes them systematically for the use of his art. Since his adolescence, he has kept daily notes, scrutinizing his dreams, his thoughts, his behavior, his relation to his parents and others, and (after he decided upon his profession) his aims, attitudes, ideas and plans as an artist. Hardly a day passes that he does not try to put into word or image some record of his experience and his thoughts.

Less speculative than empirical and analytic, Oldenburg thinks with his senses, as it were, and the art which he produces is rooted in the physical experience of his own body in relation to his surroundings. But his intense intellectual activity, and the work which results from it, are also crisply objective. His clinical self-investigation is as distant from 'narcissistic obsession'[5] as the complex thought of Freud is from popular conceptions of psychoanalysis. Oldenburg says that his first reading of Freud was 'like a curtain going up';[6] Wit and its Relation to the Unconscious was crucially important for him and is still his favorite of Freud's works.

When Oldenburg decided to become an artist, he set to work like a scientist, searching, analyzing, classifying, assessing the multiple approaches to art, the distinct qualities of different techniques, materials, and means (as color, line, volume, space, etc.). Having drawn constantly since he was a child, his hand-skill was already thoroughly developed; he now turned his attention to his intellectual self-education as an artist. The notebooks from the fifties include a careful study of earlier art from his own observations and from the literature of art; drawings illustrating various types of structure; and a complex investigation of natural phenomena. One volume, Vocabulary of Matter, deals with the effects of gravity, levity, etc. on organic and inorganic matter and the qualities of solids, fluids, heat, sound, light. Another is a Vocabulary of Space treating such factors as dimension, form, motion. These and numerous other exhaustive studies undertaken during his formative years give credence to Oldenburg's remark that he is largely self-taught in art. He had first thought he would be a writer; literature was his major study at Yale University, although he also took some courses in art, including one historical survey, especially memorable as an introduction to Focillon's poetic treatise, The Life of Forms in Art. After completing his studies at Yale in 1950, he worked for one and a half years as an apprentice reporter for the City News Bureau at Chicago. From 1952–4 he took courses in painting, figure drawing and anatomy at the Chicago Art Institute, which, together with the Yale work and a session at the Oxbow Summer School of Painting in Saugatuck, Michigan, 1953, constitute the whole of his class-room experience as an artist.

When he came to New York in 1956, he found a part-time job as an assistant in the Cooper Union Museum library, an ideal situation, allowing him ample time to study the excellent collections of publications and drawings. He spent the free half of his days observing his environment and becoming one with it. The substantial body of notes and sketches from his carefully plotted walks and bicycle trips provided rich material for his future production. Even now to walk along the Bowery, or down Orchard or across First Avenue is to walk in Oldenburg's presence, so vividly has he captured the tattered and touching life of the Lower East Side. His choosing to live and work in this area was more than an economic necessity; it was also a gesture of independence from the cultivated conventions of his background. In the living dirt of the street his unique art took root and ripened. It was further nourished and liberated by his friendship with several young artists who were also questioning established boundaries of art and were soon to extend it into live situations, environments and happenings, among them: Lucas Samaras, Red Grooms, Jim Dine, Robert Whitman, Allan Kaprow, George Segal, and the dealer Richard Bellamy.[7] Oldenburg's friendship and subsequent marriage with Pat Muschinski was another factor of extreme significance in freeing him from conventional strictures.

Having first reached artistic maturity through a slow process of inward growth, both psychological and intellectual, Oldenburg revealed himself in his New York debut[8] as a thoroughly independent talent. Held in May 1959, at the Judson Church Gallery (then just beginning to become a nerve centre of avant-garde activity in Greenwich Vil-

lage), this first show was a composite of drawings, sculpture and poems. From 1956—8 Oldenburg had written a considerable amount of poetry, much of it closely allied in theme and character to such metamorphic collages as *Obsessive shapes: man's profile, gun emplacements, or imagery out of feces,* 1957. Thereafter, he gave up poetry as such, having conscientiously analyzed his capabilities as a writer and concluded that visual art was a more suitable medium for him, since it offered more direct, physical contact with materials. However, while he did put aside poetry, he has never given up writing altogether, which is our good fortune as he continues to be the most lucid and illuminating critic of his own work. His initial exhibition is often referred to as a 'white show', but it should more properly, Oldenburg says, be designated as black, white and grey; it was basically a study of light and shadows on the street. There were also figure drawings of Pat and a few masks, among them the *Elephant Mask,* a large papier-mâché structure, which was a straightforward expression of his indebtedness to primitive ritualistic art. Although perhaps less readily detected in his later work, African, Pacific Island and other tribal sculpture continue to be significant for him. Like Picasso and many other European artists in the first decade of the century, Oldenburg was drawn to tribal art not only for its formal simplicity and concentration but, more fundamentally, for its meaning — its direct connection with natural forces and its total function as magic, to propitiate, protect, ward off evil, etc. During his exhibition, he sometimes wore the *Elephant Mask* as he walked through the streets.[9] If art is intended to express and arouse feelings, as Oldenburg's clearly is, it is hard put to do so within those conventional, academic forms and themes from which the living juice has long since been extracted. On the other hand, primitive art speaks directly from 'blood knowledge'.[10] It is this force which has attracted so many modern artists to it and to the art of the child, the insane, and the street scribbler. Oldenburg came to these sources from his own inclinations and by way of the whole history of modern art's opposition to convention. From his early years he had been interested in tribal arts and had studied the collections in the Field Museum of Natural History in Chicago, and in New York he continued his investigations at the American Museum of Natural History, the Brooklyn Museum and the Museum of the American Indian. Primitive art, as well as comics, public graffiti, children's drawings, Dubuffet's scratched wall pictures and the drawings of his friends Jim Dine and Red Grooms, were clearly in his mind as he explored his surroundings, gathered material and made drawings and constructions for his next important exhibition, on the theme of the Street.[11]

Throughout the sixties, the living body dominates Oldenburg's work although the human figure itself was never used as a model after 1959. Nonetheless, it is vividly evoked, occasionally through an isolated fragment of it, but far more often by means of allusion, metaphor and metamorphosis. A ray gun is a child's toy, but the *Empire (Papa) Ray Gun* [2] is a magnificent phallic image. It is made of

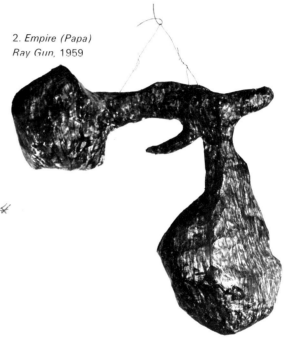

2. *Empire (Papa) Ray Gun,* 1959

newspaper soaked in wheat paste, applied over chicken wire and painted with casein. The paper, yellowed with age, has taken on a dusty gold color which emerges through the grey-black paint and adds its tone to the aura of ancient mysteries which pervades the work. The Ray Gun image occurs again and again in Oldenburg's *oeuvre*; he identifies himself with it; it is a symbol of his manhood, his vision and his art.

In the 'Ray Gun' show, held at the Judson Gallery early in 1960, Oldenburg presented *The Street* which reveals for the first time on a large scale his complete involvement with subject, material and form. Cooly watching himself do so, he took on the identity of a Bowery bum, shuffling through the city's rubbish to collect the materials from which he made the *Street* pieces: wrapping paper, cardboard, burlap garbage bags, old strings and newspapers. The colors of

Oldenburg's *Street* are New York's colors, dirty grey, black and brown; edges are charred and torn; the lines are the nervous, jagged movements of the city. 'I turned my vision *down* — the paper became a metaphor for the pavement, its walls (gutters and fences). I drew the materials found on the street — including the human. A person on the street is more *of* the street than he is a human.'[13] It may seem ironic that Oldenburg should treat humans as objects, but the fact that he does so is consistent with his entire approach (as we shall see) and, in this particular case, it is one of the methods

Autumn 1959. Happenings and environments spring ultimately from one of the historic tenets of modern art — to bring a living reality into art. The same principle motivated all of the artists whom Oldenburg persuaded to take part in the *Ray Gun Spex*, a series of happenings presented in March 1960 at the Judson Gallery during the 'Ray Gun' show. (Oldenburg had been invited by Bernard Scott, the assistant pastor of the Judson Memorial Church, to take charge of the 1959–60 season at the Gallery.) The *Ray Gun Spex* are worth listing in toto since their producers are the

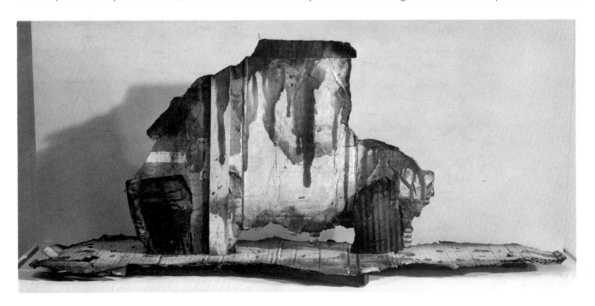

by which he expresses the bitter meaning of city life for many, if not most, of its inhabitants. Moreover, by refusing to describe human beings, but concentrating on the objects which they encounter or use in their daily lives, he paradoxically evokes their very presence, in such pieces as *Car on a Fragment of Street* [3], far more intensely and touchingly than he could do by copying their appearance.

In accordance with his concept of an exhibition as a unified whole, which he has consistently followed, Oldenburg's *Street* in the 'Ray Gun' show was in the form of a total environment, among the first of such exhibitions in New York.[14] The only work approximating such an environmental presentation which Oldenburg had seen, and was directly influenced by, was Red Grooms's happening, *The Burning Building*, given in December 1959. While he had not seen Kaprow's environmental exhibitions at the Hansa Gallery in 1958, he was affected by Kaprow's programmatic essays for a new art published in *Art News,* October 1958 ('The Legacy of Jackson Pollock'), and in *It Is,* no. 4,

masters of an art form which, by the end of the sixties, had become a household game. Oldenburg presented *Snapshots from the City,* Dine *The Smiling Workman,* Higgins *Edifices Cabarets Contributions,* Hansen *Projections,* Kaprow *Coca Cola, Shirley Cannon Ball?,* Grooms *The Big Leap* (unavoidably cancelled at the last minute), Whitman *Duet for a Small Smell.*

The Street was again the theme of Oldenburg's next one-man show, held at the Reuben Gallery in May 1960. With his characteristic sensitivity to locale, he gave this exhibition [4] in a freshly-painted, professional-looking gallery a more ordered, less dense arrangement than the ragged, helter-skelter, spontaneously dumped appearance of the first *Street* show [5] in the cramped gallery of the Judson Church. However, the comparative neatness of the Reuben show did not shut out the life of the street which informed each object in the total environment. Some measure of its vitality can be gathered from the following description written by the artist:

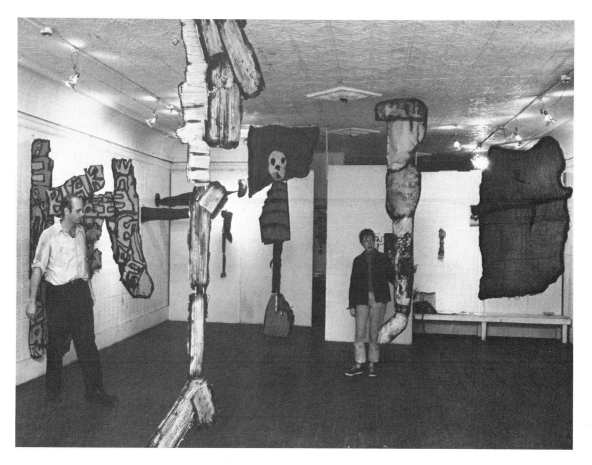

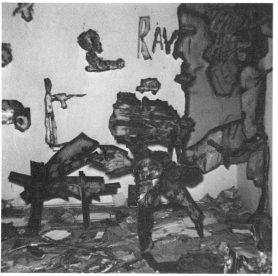

3 *(opposite). Car on a Fragment of Street,* 1960

4 *(above). The Street II*, Reuben Gallery, 1960

5 *(left). The Street I*, Judson Gallery, 1960

The show will consist of 1) an epic construction in the form of a street, 2) and 3) drawings and small sculptures and constructions also having to do with the street.

The material will be mostly paper and wood, glued paper, torn paper, paper over wire, on wooden frames, paper hanging down, paper jumping up, paper lying, etc. etc.

The scale will vary from heroic to very very small.

In The Street there will be suspended figures, standing figures, lying figures, projecting figures, falling figures, running figures, etc. etc. There will be figures on the walls, faces on the floor and a sky made of words and cries.

There will be signs of various sorts, marquees, street signs, etc. and various sorts of metamorphosed objects: cigarbutts, houses, towers, cars, medals, etc. etc. There will be faces in windows and free faces.

Hanging heads and many heads.

There will be men and women and heroes and bums and children and drunks and cripples and streetchicks and boxers and walkers and sitters and spitters and trucks and cars and bikes and manholes and stoplights and shadows and cats and doggys and bright light and darkness fires and collisions and cockroaches and mornings and evenings and guns and newspapers and pissers and cops and mamagangers and a lot more etc.

(all components of The Street can be purchased separately)[15]

While it is true that the physical conditions of the Reuben Gallery suggested a different treatment of space, that factor was only partly responsible for the character of the show presented there. In accord with his fundamental interest in opposition, Oldenburg deliberately planned the Reuben exhibition as a contrast to the previous one. *Street Chick, No-Good, The Big Guy* and all the other street characters and objects did not just occupy space; they possessed it. Painted on both sides, they floated in the air, projected several feet out from and perpendicular to the walls, or stretched out on the floor or, striding over it, extended up to the ceiling and moved across it. Consistent with their spatial activity was their energetic drawing — bold black lines abruptly changing directions like people walking on the street, or cars moving in traffic, or fragments of words and signs on blinking billboards catching the eye as one passes through the perpetual movement of the city. The design of some of the pieces, such as *'Empire' Sign with 'M' and 'I' Deleted,* even resembles somewhat the map of a city. The torn and fretted edges of the *Street* (and subsequent *Store*) pieces add immeasurably to their haunting immediacy. They are indeed, in Oldenburg's vivid phrase, 'rips out of reality'.[16]

Where colors were kept dusty and neutral and line was the dominant means of expressing the reality of *The Street,* color was allowed fullest intensity to reveal the sensuous, dream-like abundance of *The Store,* which followed it. The first glimmerings of the Store theme are found in objects and drawings executed in the summer and fall of 1960. From June to August, Oldenburg was in Provincetown on Cape Cod, having made a deliberate shift in environment intended, in his words, as 'an obliteration by non-city nature of my involvement with the city street. I took a job dishwashing, which contributed much to the technique and subject matter which were to follow in *The Store.'*[17]

Most of the Provincetown works were constructed of driftwood and other beach debris, again exemplifying his uniting of place, subject and materials, and their almost exclusive subject was the American flag, which he considered appropriate 'for a town so focused on the commercialization of patriotism and history'.[18] Some of the first Store objects were again flags, but then in full color rather than in the silvered grays and browns washed by the sea.

In the fall of 1960, he began a series of watercolors and drawings of store windows and merchandise, and early the next year he constructed his first three-dimensional Store pieces of muslin soaked in plaster, built up over chicken wire and brightly colored with commercial house paints. For Oldenburg the outdoor Street pieces, with their angular planes and lines in subdued colors, were male in essence, while the Store's luxuriantly colored objects of cloth and plaster in undulating forms and glistening surface, were fundamentally female. Delighting as he always has in contradiction, he frequently combines these opposing motifs within a single work. Regarding one of the first such combinations he writes, 'In *Circus (Fotodeath/Ironworks),* a performance of February 1961, the stage is divided into halves, one in black, white and neutrals, and the other in rich color. The contrasting color schemes are identified in the script as "male" and "female". The color, softness, and lubricity of the store material is considered "feminine".'[19]

A first version, or preview as it were, of *The Store* was shown at the Martha Jackson Gallery, 25 May — 23 June, 1961, in the *Environments, Situations, Spaces* exhibition. The statement which Oldenburg wrote for the catalog has become one of the primary documents of modern art. Since it has been published, a brief excerpt, to give its flavor, is sufficient here.

I am for an art that does something other than sit on its ass in a museum. I am for an art that grows up not knowing it is art at all, an art given the chance of having a starting point of zero. I am for an art that involves itself with the

everyday crap and still comes out on top. I am for an art that
imitates the human, that is comic if necessary, or violent, or
whatever is necessary. I am for an art that takes its form from
the lines of life, that twists and extends impossibly and
accumulates and spits and drips, and is sweet and stupid as
life itself. I am for an artist who vanishes, turning up in a
white cap, painting signs or hallways.

I am for art that comes out of a chimney like black hair
and scatters in the sky. I am for art that spills out of an old
man's purse when he is bounced off a passing fender. I am
for the art out of a doggy's mouth, falling five floors from the
roof. I am for the art that a kid licks, after peeling away the
wrapper. I am for an art that joggles like everyone's knees on
a bus . . .[20]

The pieces in the Martha Jackson show were primarily
reliefs, but he soon added more free-standing objects to the
Store's stock. Having rented as a studio an actual store at
107 East 2nd Street, it was inevitable, given his disposition
to live himself into his work and make a totality of it, that he
would set up a real store, producing his wares in the back
rooms and marketing them in the front. He called his estab-
lishment the 'Ray Gun Manufacturing Co.' and the theatrical
performances which followed in the same locale, 'The Ray
Gun Theater'.

6. *Store Days I,* at Ray Gun Theater, 1962

Oldenburg's *Store Days,* a publication of documents
selected by himself and Emmett Williams from the note-
books and other studio archives, presents a vivid account of
the genesis, production and history of the Store (and the
performance entitled *Store Days*). One shares the artist's
excitement as he writes,' . . . forget the commercialism and
vanity of the long-prepared show. A show is the gesture of
being alive, . . . a look into one's continuing daily activity'.[21]

And as the idea suddenly strikes him.

> *'actually make a store!*
> *14 st or 6 ave*
> *butchershop, etc.*
> *the whole store an apotheosis!*
>
> *a sad, past, hi(stor)ical store*
> *a happy contemporary store too?'*[22]

In addition to the value of its content, the book's mise-en-
page gives something of the visual character of the note-
books, i.e. the form in which words, phrases and images are
placed on the page, which is related to what Oldenburg calls
his 'scrap method' and ultimately to the meaning of his
accumulation of fragments.[23]

The Store [11] was opened to the public at the Ray
Gun Manufacturing Co. on 1 December 1961 and extended

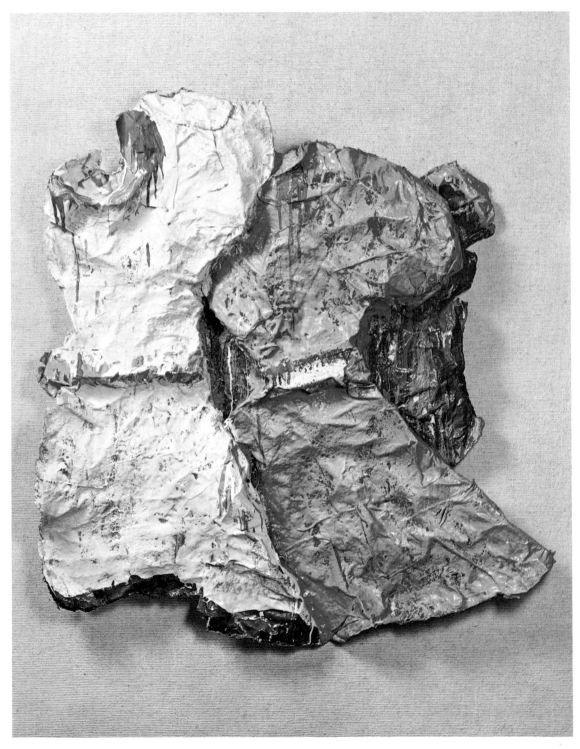

7. *Girls' Dresses Blowing in the Wind,* 1961

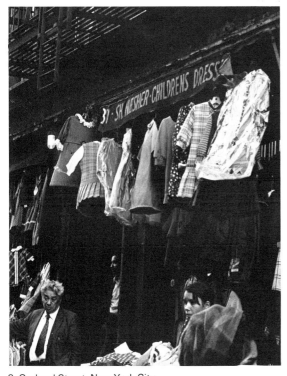

8. Orchard Street, New York City

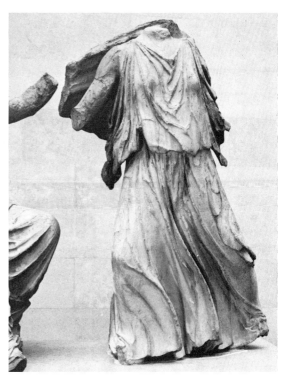

9. Figure of Hebe, from Parthenon Pediment,
Elgin marbles, British Museum

through January 1962, a month beyond its scheduled closing. While it did not bring Everyman in from the street, it did bring artists and a small group of advanced collectors and critics who realized that it was *about* Everyman and his — or her — world of commodities and advertisements, and about the contrast between those objects and the created objects derived from them. Oldenburg's *Store* was about art and about fact and fantasy, ambiguity, eroticism, and materialism. It was about idealism and freedom, mobility and change, and about life and death in life. *The Store* was about almost as many things as there were people who saw it and objects in it, objects whose intense existence is imbued with the plastic life which Oldenburg gave to them, and with the life of the human beings whose needs, desires and emotions they signify and educe: a pair of white tennis shoes as touching as Van Gogh's old worn ones; shirts which still hold the shape and warmth of a man's body; a brown jacket whose brutal elegance Manet would have understood; two dresses [7] which quiver with the movements of a young girl or dance in the wind as their prototypes do on Orchard Street [8] and on the figures

from the Parthenon pediment [9].[24] A crumpled airmail letter quickens the heart. Foodstuffs tease the palate. Like the store next door and around the corner, Oldenburg's offered bread, cake, pies, carrots, sausage and 7-Up; but the function of his food is to sustain the mind and heart, not the body. And in his Store a mannikin, dressed in white with veil and corsage, but resembling a corpse more than a bride, dominated the material abundance like the mummy case confronting the guests at an Egyptian banquet. However, while Oldenburg is deeply conscious of death's eternal presence and welcomes it as essential to life, *The Store,* like all of his work, is primarily in praise of 'how it feels to be alive'.[25]

Oldenburg's objects imply a human act. One ties a shoe lace, struggles into a swimsuit, rings up sales and makes change from a cash register. Movement, implicit in the subject, is made explicit in every aspect of the form. Respecting and encouraging the qualities of chickenwire, Oldenburg does not conceal it beneath a thick mass of the plaster, but brings it right up to the surface to reveal its undulating contours and sudden edges as the basic

structure of the work. Further, he accentuates its activity in the splashes and rivulets of paint riding over the moving volumes. Thus, support, ground and surface become one in the three-dimensional Store pieces, which are like paintings that bulge and retreat as though pushed from within. Color (red, yellow, orange, white, intensified by contrast with green and blue) adds its power of expansion to the internal energy of the forms.

Living mobility, apparently spontaneous but subtly directed, also characterizes Oldenburg's happenings presented at the Ray Gun Theater in the late winter and spring of 1962. His work in this genre is yet another phase of what he calls 'the poetry of everywhere'.[26] Here, too, he combines fact with fantasy to convey the magic which dwells in the most common events or simple objects. By isolating and fixing on an ordinary everyday act or one stage of it, as he does with a single object or fragment in his plastic art, he gives to his happenings the strange intensity of hallucination, sometimes carried to the edge of terror. Reading the script for Store Days, or other Oldenburg happenings,[27] gives one some idea of the richness of his imagination, his concentration combined with tumultuous variety, his violence and lyricism, his love of objects and the activity he assigns to them, the exactitude and flexibility of his directing. There is no plot and no dialogue. He gives his actors a general plan but does not tell them what to do; particularly in the early years, he knew his cast so well that he could rely upon them to improvise in accordance with his general intention. They (his wife Pat, Lucas Samaras, Gloria Graves, Billy Klüver, Henry Geldzahler, among others) were treated as objects and they behaved like objects, their faces totally without expression or fixed in a mask-like grimace. Oldenburg has referred to his performances as a 'theater of objects'. His attitude is indirectly revealed in the following line from the 'Store Days II' script, 'No one is in the room but the objects.'[28] While reading an Oldenburg script is certainly illuminating, it is a far cry from being present at one of his productions. Attendance at the Ray Gun Theater was limited to thirty-five persons — initiates, as it were — who stood in a close narrow space in total darkness, interrupted at programmed intervals by light from a bare or half-shaded bulb [6]. In such conditions, touched by other spectators and even the actors, sometimes mysteriously brushed across the face by the hair or leg of a playful 'spirit', one becomes hyper-aware of the body. One feels oneself standing, balancing, breathing, or holding one's breath. In Oldenburg's 'physical theater',[29] all of one's senses become so extraordinarily acute that even time is perceived sensuously — drawn out, expanded, contracted or suspended. Oldenburg's treatment of time as almost a tangible thing is an important factor in creating the ritualistic character of his performances and their relationship to contemporary dance. He would probably see no more distinction between dance and his kind of theater than he does between theater and the plastic arts. He says, 'Distinctions I suppose are a civilized disease . . . I see primarily the need to reflect life . . . to give back, which is the only activity that gives man dignity.'[30]

There is, thus, a lively give and take between Oldenburg's happenings and his other art in subject matter, materials, style and content. Most of the objects which were such important characters in his theater were actually pieces of sculpture in themselves, as well as influencing and anticipating formal developments in the independent sculpture exhibited later. For example, the Upside Down City [10] used in World's Fair II, presented at the Ray Gun Theater, is one of several props made of sewn and stuffed material which played a role in the genesis of his soft sculpture, an innovation of decisive importance in contemporary art. In his commentary for the 'Documents of the Ray Gun Theater', presented at the Museum of Modern Art in New York, 22 October 1969, Oldenburg said, 'Many other possibilities for subject matter and materials were discovered and tested in the performances. It was really a workshop in natural effects. I tried to restage whatever captured my interest in life around me. The theater was indispensable to developing an art such as mine which grows out of contact with reality.'

The visual reality which Oldenburg celebrated in The Store [11] is primarily the already once-removed, artificial 'reality' of advertisements and other popular American images. The style of such source material is a basic subject and concern of The Store, as it is of all the art that became known as 'pop'. At that time, 1961 and early 1962, several artists, many of them unknown to each other, were involved in similar thematic and stylistic interests; this fact was noted by a few astute dealers and museum curators. In November 1962, the Sidney Janis Gallery staged a large exhibition (renting additional quarters) of New Realists, bringing together for the first time the work of these Americans and showing it along with that of several Europeans. From March to June 1963, the Guggenheim Museum presented 'Six Painters and the Object',[31] organized by Lawrence Alloway, who had been closely associated with the origins of the pop movement in England; and in April, the Washington Gallery of Modern Art opened its 'Popular Image' exhibi-

10. Upside Down City,
prop from World's Fair II, at Ray Gun Theater, 1962

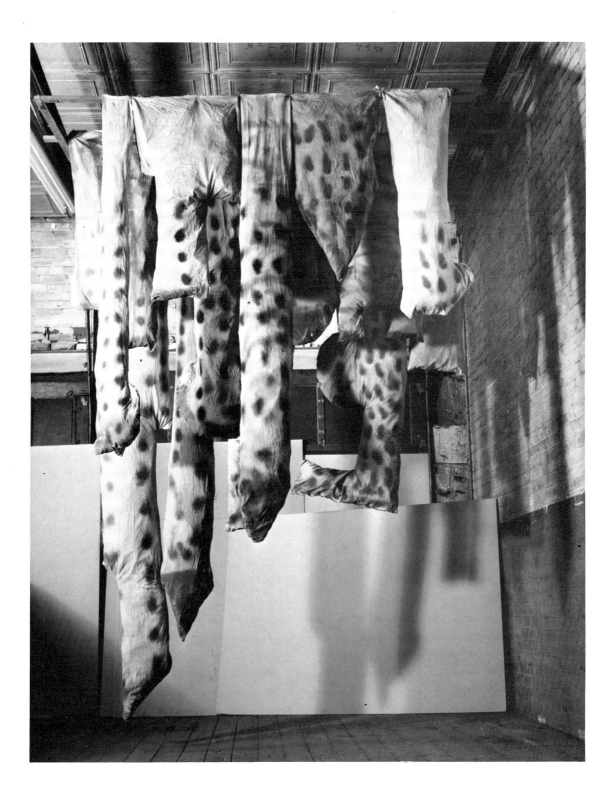

tion, documented by a recording of interviews with the artists and accompanied by a lively program of lectures, dance, and an Oldenburg happening, *Stars.* By the end of 1963, the designation 'pop' was firmly, and unfortunately, fixed in the public mind. Unfortunate, because the act of identifying a work as 'pop' too often took the place of seeing it, and because these artists never formed a group but continued to pursue their individual styles and interests within their common general concerns. Even the most casual layman could not confuse an Oldenburg with a Warhol with a Lichtenstein with a Dine with a Rosenquist.

Oldenburg spent part of the summer of 1962 tidying up his store-studio, restoring damaged items, sorting out the accumulation of sets and props from the performances, carefully classifying and saving pieces of value as independent objects and as seminal material for further production. He noted with respect to the 'residual objects' which he slowly studied and listed, 'The floor of the stage is like the

street. Picking up after is creative. Also their particular life must be respected.'[32] Putting to work what he garnered from these weeks of analysis and assessment, he prepared for his show at the Green Gallery in September.

The relatively large size of the Green Gallery (at that time it seemed very large indeed) gave *lebensraum* to Oldenburg's predilection for works on a grand scale. It was here that he introduced his colossal sewn sculptures: a piece of cake 5 x 9 x 4 feet, a hamburger 7 feet in diameter [13], and a 10-foot long ice cream cone. As usual, he prepared the show as a unit for a particular space, and the work inevitably reflected the uptown area of Manhattan where he spent a good deal of the summer. As he had been invited to use the gallery as a studio, he literally made the soft pieces right in the space where they were to be exhibited; he and his wife Pat stitched them on a sewing-machine and, after stuffing the canvas with foam rubber and paper cartons, he painted them with liquitex and latex. He has likened the large

11. *The Store*, 1961

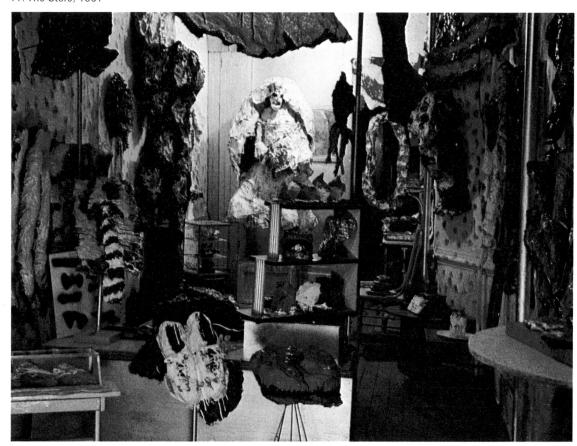

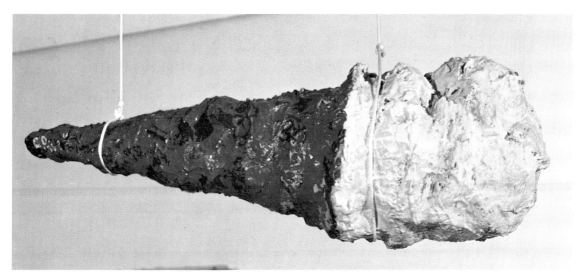

12. *(Giant) Ice Cream Cone,* 1962

13. *Floor-Burger,* 1962

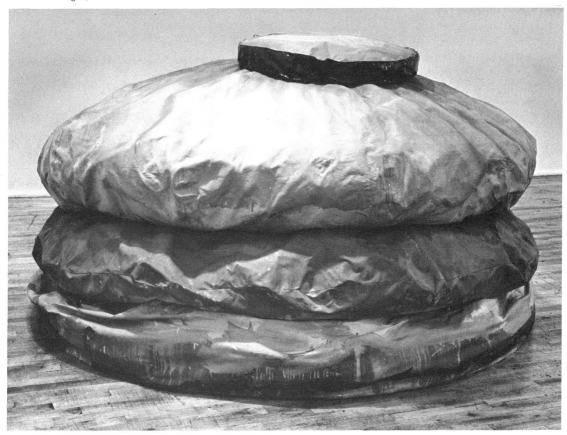

sculptures lying on the floor of the gallery to the auto-
mobiles displayed in the shop windows near the Green
Gallery on 57th Street. Thus, his response to advertising and
environment again figures in the origins of a new mode.
Among other sources and motivations for the large sewn
sculpture, besides happenings and the Street heads referred
to earlier, was the wish to provide Pat with an essential part
of the work (as she had had in the performances) as well as
the practicality of the medium, making it possible to execute
sculpture on a large scale at a minimal cost. The possibility
for gigantic size also gave scope to his fantasy and provided
an excellent vehicle for his humor and ironical wit. A cloth
ice cream cone is funny enough in itself, but to make it ten
feet long is a colossal contradiction. At the same time, in
these majestic sculptures lurks an ominous note, which
frequently underlies his most light-hearted looking work.
The dry surface of these canvas pieces, covered with matte
paint in neutral, earth colors, enhances the austerity of their
starkly simplified and enlarged forms. Besides the mon-
strous, popular American food trio, there were other works
in the same medium (an enormous pair of pants, a calendar
for the month of August, a box of miniature objects),[33] as
well as several items in the more familiar plaster with high
gloss finish, such as the *(Giant) Ice Cream Cone* [12] hang-
ing from the ceiling. Its luscious rippling and melting sur-
face is in direct antithesis to the dry *Floor-Burger* [13]; but
both works are clearly from the same mind in their positive
assertion of basic forms and in their thematic significance.
Beyond their ostensible subject of American food, both are
sexual images, the hamburger primarily female with its
multiple layers of circular forms, the cone phallic in shape,
and its 'concupiscent curds' both male and female. The
startling image for ice cream is from Wallace Stevens' poem,
'The Emperor of Ice-Cream'. One of Oldenburg's analogues,
from the 1963 Notes, reads 'Ice cream = God = Sperm.'
Both Stevens and Oldenburg delight in contrasts and both
profoundly respect ordinary reality and find in its facts the
presence and symbols of deeper meaning. A veiled theme
in 'The Emperor of Ice-Cream' is explicitly voiced in a line
from another of Stevens's poems, *'Sunday Morning'*,
'Death is the mother of beauty'. This idea is often implied
in the work of Oldenburg who once wrote, 'The presence of
death defines life'.[34] The *Bride* is a ghostly mannikin; Eros,
ever present, is ever wedded with Death.

Recently Oldenburg wrote,

Oldenburg + ice bag = iceberg
Iceberg = Oldenburg
Ice cream cone = prince of death, or his habitation.[35]

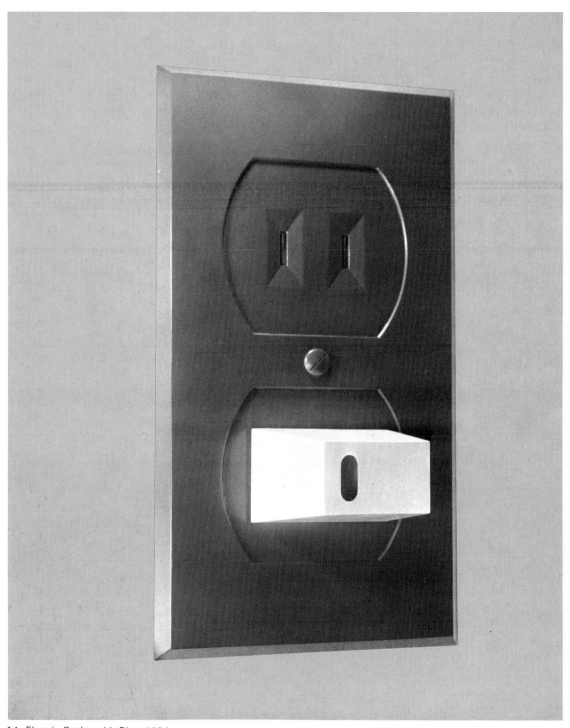

14. *Electric Outlet with Plug,* 1964

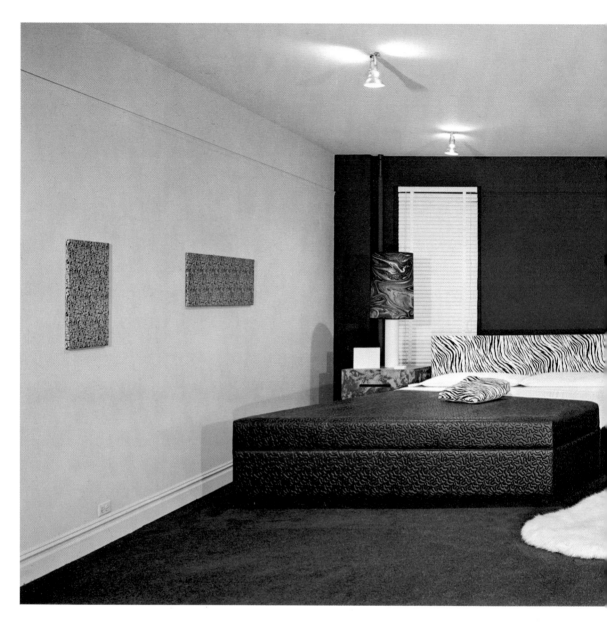

15. *Bedroom Ensemble*, 1963

This series of equations progresses from a simple play on words to a profoundly provocative — but not unexpected — conclusion, which is related to his saying that he does not allow human figures to appear in the work except 'as dolls, mannikins, in "pornography", as little anonymous figures in architectural models, and always as corpses'.[36]

All of these thematic and visual concerns are brilliantly synthesized in Oldenburg's next major work, the *Bedroom*

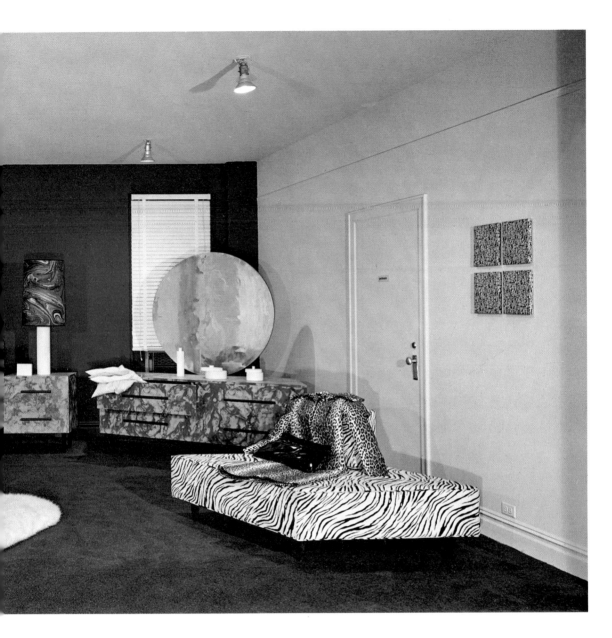

Ensemble [15], designed for the front room of the Sidney Janis Gallery in the 'Four Environments' show, January 1964. Oldenburg constructed a replica[37] of the *Bedroom* (now in the Karl Ströher collection, Darmstadt) for the 'Pop Art' exhibition held at the Hayward Gallery, London, in the summer of 1969. The architectural shell in which it was placed faithfully reproduced, even to the door and windows and air conditioner, the original site for which it was conceived. This consistency was maintained in the installation of the original version at the Museum of Modern Art, New York, in the Oldenburg retrospective exhibition from September to November 1969. In the *Bedroom Ensemble* the dwelling of Eros becomes a chamber of death. It is embalmed in the falsity of both reason and appearance, in the chilling geometry of perspective illusion, and in the synthetic nature of the entire decor, with its manufactured

tiger and blue marble formica furniture, black vinyl bedcover and textile Tobeys or Pollocks. Chaining it off from its surroundings is unnecessary; its remoteness is intrinsic. No woman will ever curl up on the chair or dream before the mirror; the gorgeous bed will never creak.

The *Bedroom Ensemble* can also be interpreted quite differently. In it Oldenburg is not only 'upholstering perspective', as he says; but he is actually making geometry sensuous. He does so through a characteristically witty reversal or twist. By presenting objects in the rhomboidal shapes which they assume when rendered on a two-dimensional surface according to the laws of scientific perspective, he transforms 'the rationalization of sight'[38] into a physical fact.

Oldenburg has explained that the *Bedroom Ensemble* was partially based on his memory of a west-coast motel, which he had visited in 1947, where the suites were decorated each in a different animal skin. He planned and executed the work in the fall of 1963 in Los Angeles, to which he had moved that summer in one of his deliberate changes of environmental stimulus. While the *Bedroom* was created especially for the Janis Gallery in New York, its style and concept reflect his response to the Los Angeles situation: the ready availability and abundance of plastic and other synthetic materials, the large scale, spaciousness, physical and social openness, and what Oldenburg speaks of as its 'home-consciousness' in contrast to the street-store-business-restaurant-anywhere-but-home centered activities of New York.

While Los Angeles is, thus, partly responsible for Oldenburg's third major theme, the Home, of which the *Bedroom Ensemble* is the most ambitious individual work, that motif did not originate from any single stimulus; in fact, it quite naturally evolved from the previous preoccupations. The street, the store, (and, by implication, the shop or business) and the home are the main arenas of our daily existence.

Moreover, all three themes overlap from one period to another; pickles, potato chips and French fries shared space with ironing-board, vacuum cleaner, typewriter and ping-pong table in his April 1964 one-man show. But the new sculptures were stylistically all of a piece, and a very different piece indeed from the *Store* works. Gone were the torn, nervous edges and the shifting layers of strident color in dynamic lines and splashes. The total coloristic effect of the new show was black and white and silver, emphasized by contrast with a few accents of clear, unvaried color: red *(French Fries and Ketchup)*, blue *(Pool Shapes)*, green *(Green Beans)*. The *Soft Typewriter* and the *Electric Outlet with Plug*, like the *Bedroom Ensemble*, look cooler, more

industrially finished and anonymous in their uniform surfaces and frequent sharp edges and corners, combined with, or played against, soft, irregular and curving forms. Such synthetic materials as vinyl, formica, acetate, plexiglas seem a further step removed from organic reality than canvas, plaster, muslin and chickenwire. Depersonalization was heightened by increased use of assistants besides his wife — other stitchers and carpenters. But even now (1970), when Oldenburg is having several pieces executed industrially, he works hand in hand with the manufacturer, suggesting and modifying in a continuous give and take between the physical propensities of material and its expressive and formal possibilities. Moreover, his thinking is so physically oriented that the interchange between material and form would take place in his mind even if he did not actually construct numerous sketches and models as he still continues to do.

In 1963, to use vinyl was a daring idea for a fashion designer;[39] how much more so for a sculptor. But Oldenburg did it and thereby solved the problem of how to make reasonably durable sculpture become yielding and unfixed, and, at the same time, give it some of the visual properties of the source object's metal or other firm material. While anonymity and objectivity are factors in the artist's attitude, the works themselves are so distinctly personal that it is difficult to look, for example, at any typewriter without thinking of Oldenburg's completely relaxed and useless one. When its hard plexiglas keys, randomly placed on the boneless vinyl, are struck, the machine just settles into another comfortable position. Contradicting the properties of the original object emphasizes the qualities of the created object, as was true of the gigantic edibles of the year before. However, there is an additional twist to the irony here in that the source typewriter, toaster, and telephone are hard, whereas a hamburger, ice cream cone and cake are soft to begin with. There are other differences: the floor pieces of canvas stuffed with shredded foam and cardboard cartons are more set in their forms; they do not have the melting mobility of the vinyl pieces. Moreover, practicality and necessity played some role in the genesis of the earlier sewn pieces; as was indicated above, he wanted to make pieces commensurate with the space in the Green Gallery and he had to make them cheaply and quickly. But, such external considerations had no real bearing upon the construction of the typewriter, toaster, etc. which were made in full consciousness and deliberation *as* soft sculpture. In 1964 Oldenburg said, 'If I didn't think that what I was doing had something to do with enlarging the boundaries of art, I wouldn't go on doing it. I think, for example, the reason I

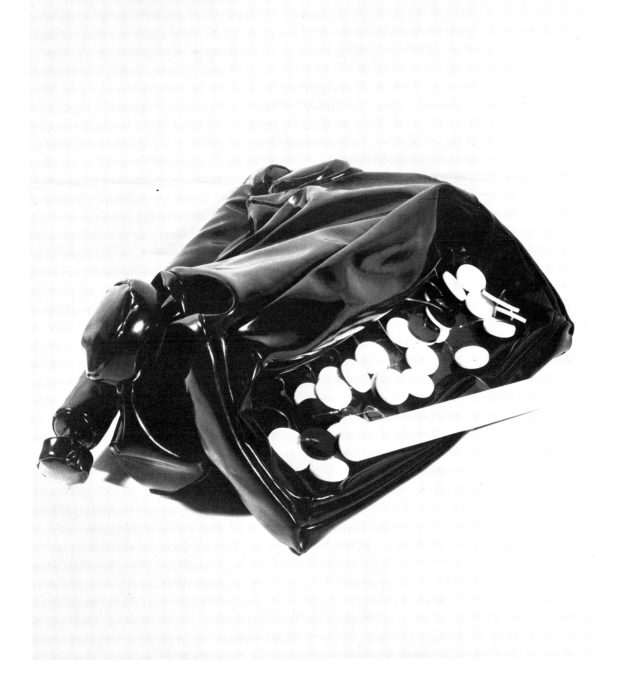

16. *Soft Typewriter*, 1963

17. *Tub (Hard Model)*, 1966

18. *Soft Tub – 'Ghost' Version*, 1966

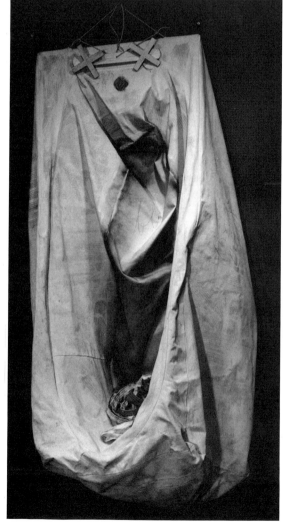

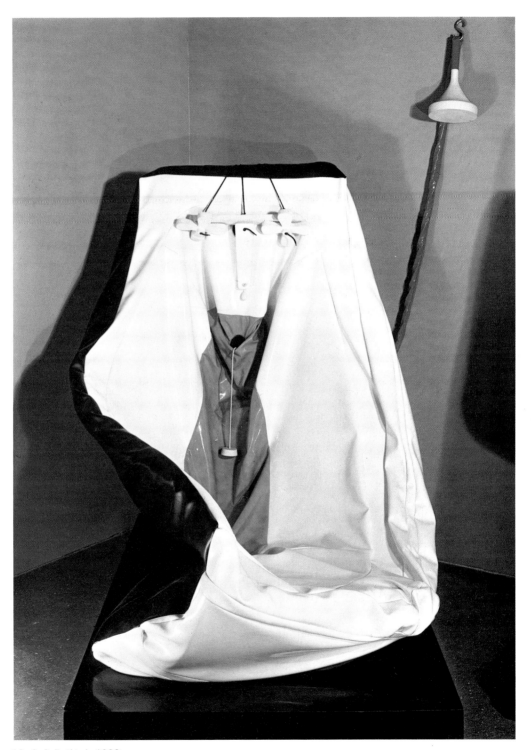

19. *Soft Bathtub,* 1966

have done a soft object is primarily to introduce a new way of pushing space around in a sculpture or painting.'[40] Thus, while it is true that Oldenburg did make some sculptures of soft materials for the performances, the *Street* and even before that, it is also correct to say that he did not make soft sculpture *per se* until early 1963.

Another difference in intent and form is that in the later works he is more concerned with volume than in such pieces as the *Floor-Burger* [13] which, in spite of the amount of space it displaces, has a planar look about it, like a series of flat layers which had somehow become inflated. In contrast to the gigantic hamburger, the *Soft Typewriter* [16] , which is not so very much more than normal size, appears somewhat more volumetric, even though its volumes slip and slither about, never falling into quite the same disposition of forms. In the photograph chosen for reproduction here, the piece is seen in as deflated and pushed together a state as possible; but even so, it erupts out into space with far more internal energy than the *Floor-Burger*, which just sits there. The 'ghost' version (i.e. the white, lightly painted canvas model) is even more pliant and variable than the finished vinyl.

In the Bathroom series, begun in 1965 and exhibited in March 1966, Oldenburg executed several of the items in three versions, each with an entirely different wedding of form and material and consequent meaning. The *Tub (Hard Model)* [17], constructed of corrugated cardboard thinly scumbled over with enamel paint, is closed in upon itself, remote, silent and austere. The 'ghost' version [18] is an exploration of the technical possibilities of working out the form in sewing, and an independently beautiful sculpture in itself. For many observers, it is perhaps the most difficult of the three, with its disquieting combination of forbidding and sensuous, of dry texture and voluptuous folds, which suggest viscera and female sexual body parts. The vinyl *Soft Bathtub* [19] images more explicitly the smooth and shining white porcelain, blue water and red shower hose, while retaining the voluptuous body imagery. More confident, even boisterous, in its elegance, it conjures up a vision of Mae West sashaying down the stairs. (The ghost version is more aristocratic, while equally sensuous.) So successful is Oldenburg in the soft sculpture, with which he identifies his own body, that the observer responds empathetically: one feels the long folds of the *Soft Bathtub* flow like water over one's body in utter lassitude. The vitreous-looking surface implies that the white vinyl tub has inner rigidity; but actually it is almost a living being as it constantly changes its form in response to gravity and touch. Soft and giving as human flesh, the pliant material is

the means by which the artist can 'push space around'. The mutability of the soft sculptures, especially the ghost versions, is so pronounced that the element of time is implied as their forms shift and change like an embryo in process of growth and becoming. This factor is increased in those pieces which are composed of repeated units, each of which can be arranged in a variety of positions. For example, the handles of the *Four Soft Dormeyer Mixers – 'Ghost' Version* [20] can be raised or lowered so that they project out into space at different angles, instead of all being in parallel relation to the wall, like a relief, as they are disposed in this photograph. While Oldenburg's work in general can be regarded as a brilliant metaphor of mobility and change, in his invention of soft sculpture he goes beyond metaphor or illusion and presents those qualities of flux and mutability directly, in actual, physical fact.

In the Home, as in the earlier themes, Oldenburg continues to present the human body through metamorphosis and analogy with things which we touch and use every day. And bathtub, light switches and Dormeyer mixers join together in celebrating the mystery of sex and fertility. Both male and female in its body images, the *Soft Light Switches* [21] with its pink color and lubricous surface, is tumescent with life, like a creature fresh from the womb.

Concurrent with the soft fleshy pieces are hard sculptures of the utmost severity, such as the painted wood *Electric Outlet with Plug* [14] of 1964. The straight edges of this tersely simplified, monumental form cut sharply into space. The color of the piece, dark brick-red with white plug, warms its cool geometry. Although at first glance it may appear completely unrelated to the *Soft Light Switches*, a little more looking reveals their fundamental similarities: bilateral symmetry, stripped-down, emblematic form, hallucinatory scale and stubborn existence. It is worth noting that, except for scale, these are qualities which they have in common with African sculpture.

Between the *Electric Outlet with Plug* of early 1964 and the Bathroom series of 1965–6, Oldenburg interrupted work on the Home theme during several months spent in Europe, beginning with a spring trip to Venice, where his work was shown at the Biennale, and culminating in a fall exhibition at the Ileana Sonnabend Gallery in Paris. If the French had expected to see giant hamburgers, ice cream cones and garish American ads, they were disappointed; inevitably, Oldenburg selected his subjects from what he found most distinctive and ubiquitous in Paris – its *charcuteries*, *pâtisseries*, and *épiceries*. And just as clearly, his exhibition was about the Parisian style, not just the pretty way of

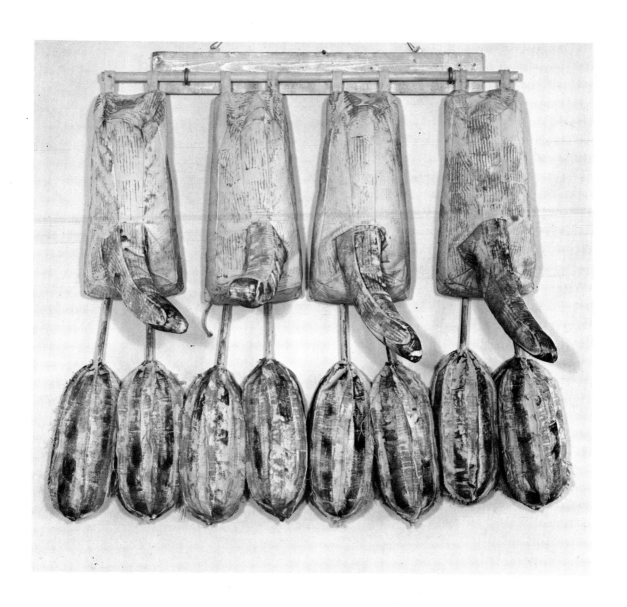

20. *Four Soft Dormeyer Mixers – 'Ghost' Version,* 1965

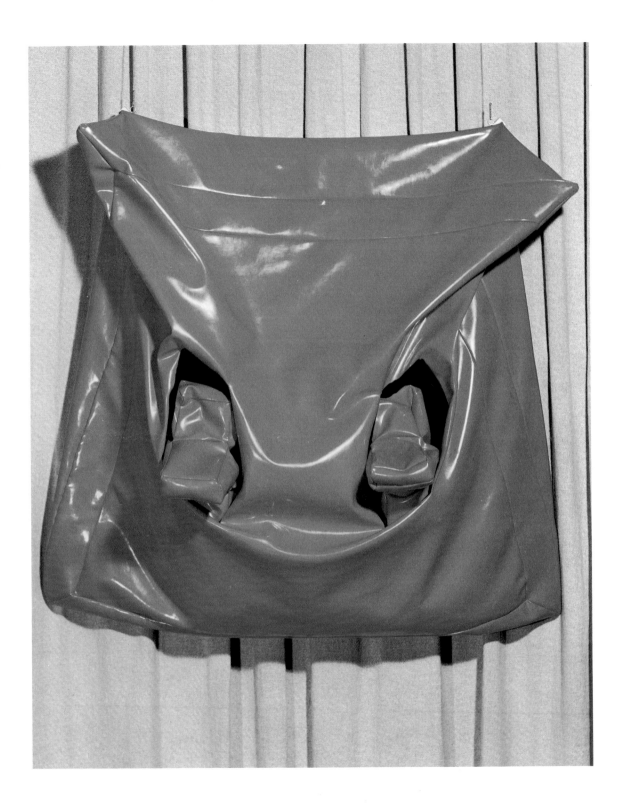

arranging meats and pastry, but the mellow elegance of the whole city and its art. Instead of the brightly colored, glossy enamel with which he painted his American food pieces, for the French delicacies he used muted colors, usually with considerable admixture of white, in non-reflective tempera paint, thinly applied over plaster to give a chalky quality, like the old walls of Paris. In most cases, as in *Glace en dégustation, Oeufs Vulcania,* and *Viandes (Meat Counter)* [22], he leaves the plaster unpainted to stand for ice cream, egg white, fat, etc. and to state unequivocally the material qualities of plaster itself. But Oldenburg's *Viandes,* displayed on porcelain plates and marble slabs, and colored in rose, dusky warm and silvery pinks, lavender, pale ocher, white and grey, says at least as much about the paintings of Chardin and Manet as it does about French *charcuteries* and *boucheries.* This three-dimensional piece is an aristocratic painting made tangible; its individual elements can be picked up, handled, caressed, and reassembled differently

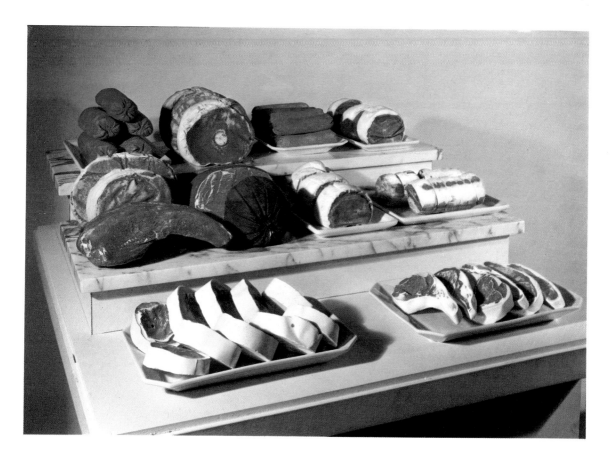

21 *(opposite). Soft Light Switches,* 1964

22. *Viandes (Meat Counter),* 1964

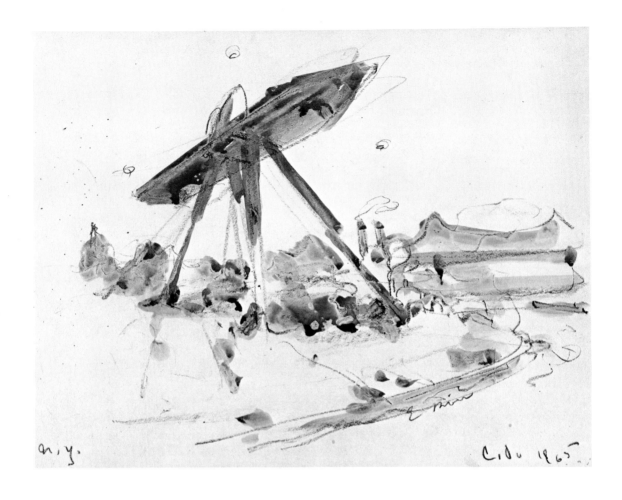

23. *Proposed Colossal Monument for Lower East Side: Ironing Board,* 1965

as the artist or the owner desires. Once more Oldenburg's work deliberately invites the spectator's direct, physical experience of it.

Some of the pieces in the Paris show, as *Glace en dégustation*, for example, deal with a natural phenomenon which is a frequent theme for Oldenburg and a corollary of his concern with time, i.e. the object in process of being consumed. The very subject of the work is the actual metamorphosis from one state and form to another, implying the passage of time and the cycle of life, death, decay and rebirth.

In March 1965, a few months after his return to New York, Oldenburg rented a loft on 14th Street. Its enormous size, a city block in length, made it possible to construct and store gigantic pieces (suspending some of them from the high ceilings), and it further stimulated his scale fantasies. Soon after moving to the new studio, he began a series of drawings called 'colossal monument proposals', some of which were exhibited in a group show at the Janis Gallery in May 1965. They are views of various sections of New York in each of which is placed an enormous common object (vacuum cleaner, frankfurter, teddy bear) which Oldenburg deemed appropriate in subject and form for the particular site. For example, he calls attention in his notes to the way in which the ironing board for the Lower East Side [23] 'echoes the shape of Manhattan island and also "shields" the vanishing ghetto, commemorating the million miles of devoted ironing'.[41] His imagination plays with the possible functions of the proposed monuments. For the ironing board, 'The top . . . serves as a landing place for helicopters. Passengers and visitors eat at the restaurant hung under the board, recalling the cabin of a zeppelin. They descend by diagonal elevators through the "legs".'[42] In 1965 he made thirty-three of these drawings, all of them for New York ('I made toys for it, my city of cities'[43]): a half-peeled banana for Times Square, a soft Good Humor Bar to sheathe or replace the Pan Am building on Park Avenue, and a teddy bear for Central Park North. When asked, on the occasion of a lecture at the Bath Academy of Art, 'Why a teddy bear?', he spoke of childhood memories and the fact that he still has several teddy bears which are considered a 'tiresome sentimental subject and I often choose something that is discredited that way and see if I can bring it off as a dignified piece.' He called it a 'source of pathos – doesn't really have any hands or feet . . . as if they'd been chopped off . . . the helplessness of the city person and specifically of the negro in New York. I mean to change existing conditions, and that may be why this teddy bear is sitting up at that end of the park which is the Harlem end.'[44]

Oldenburg did not make this particular piece, or any other, as a conscious illustration of a sociological idea; the work is visual in inception, but the visual idea is compounded of a variety of associations and is open to multiple interpretations. He clarifies this question in a 1967 notation: 'To say that one is a social artist could mean, as it does in my case, that an artist is responsive to events or form of events around him. He isn't making a statement about the events but reflecting them in his form and color. This happens for me without preconception.'[45] In the introduction to his book on the monument proposals he states, 'The project began as a play with scale and that's what it seems to be about – the poetry of scale.'[46]

In 1966 during several months spent in Stockholm and London, in connection with major exhibitions of his work, he devised several marvelous monuments for those cities: a wingnut for Karlaplan and a doorhandle and locks for the area behind Moderna Museet in Stockholm (Sweden's hardware is as famous as its *knäckebröd*, the subject of another of his works), a lipstick to replace the fountain of Eros in Piccadilly Circus, a copper ball (a toilet float) and a knee for the Thames. As the clippings in his London notebooks demonstrate, the view of girls' knees was inescapable. 'Oxford St was a sea of knees' and his own ached constantly from the cold.[47] The *Thames Ball* [24] is a huge concentration of orange and red, a generator of color and light – a sun for London.

The majority of the monument proposals, and all of the early ones, are pure fantasies, their impossibility of realization being part of their *raison d'être*. However, among the later ones are some which he classifies as 'feasible' rather than 'colossal'. Several of these are more architectural in form; a huge clothespin, a *Late Submission to the Chicago Tribune Architectural Competition of 1922*, looks as though it would be more practicable to construct than an enormous teddy bear, for example. The variety of styles in the monument proposals is a partial index of Oldenburg's range as a draughtsman. Many of them, especially the early ones, like the *Ironing Board*, are in an idiom which he alludes to as 'impressionist'. Crayon and watercolor hit the page in quick and swinging gestures, loosely but firmly defining structure, space and light. The environment in which the monument sits is suggested, not described, by a few summary strokes and washes; contours open and give onto the white of the paper, which lets the eye move freely over the page and allows plenty of 'breathing' space. In the *Ironing Board* numerous little spatters contribute to the immediacy which distinguishes all of these drawings. This kind of calligraphy is, as a whole, very similar to that which he had developed

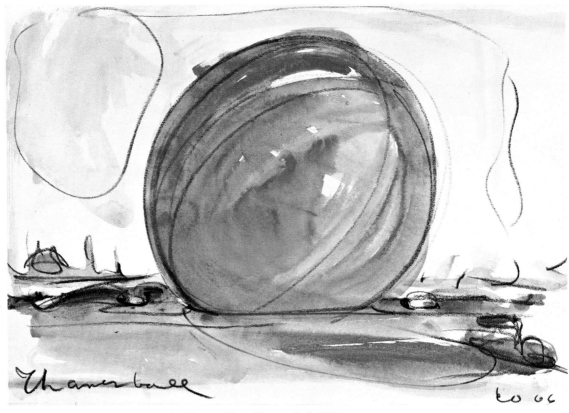

24. *Proposed Colossal Monument for Thames River: Thames Ball*, 1966

for a series of landscape drawings done at Lenox, Massachusetts in the summer of 1959. It is understandable that an artist, and particularly Oldenburg who never wastes anything, should refer to a system which he had previously devised for landscape when he again turned to that genre. The colossal monument drawings are indeed landscapes (or cityscapes), but presented as though viewed from a cruising plane and combined with still-life objects no farther away from the artist's eyes than his hand. The London water-colors preserve the luminous and open character of the earlier ones, but are freer of mannerisms. In contrast to this hurried 'impressionist' type, are pencil drawings of extreme delicacy and precision; the drawing of doorhandle and locks rising above Stockholm[48] brings to mind Ingres's views of Rome. There are also explicit technical drawings, mathematically accurate for precise execution of a work; and there are other studied drawings with much hatching and cross-hatching which, he says, reflect his interest in '19th century English and German classicistic-romantic

drawings' (he finds this style particularly appropriate, and most often uses it, in his erotic drawings). Some of the drawings are agitated, some calm, some threatening; a few are carefully worked but more are impulsive, and several are as bold and commanding as the *Sketch of a 3-Way Plug* [25] of 1965. While this last is not a colossal monument proposal, it is a vivid example of Oldenburg's power as a draughtsman. When one looks through a collection of his graphic work (drawings, prints and posters), it seems inevitable that he would eventually construct large monuments, as he now does, considering the monumental scale and the power of expansion which he could give to the drawing of a hamburger or a piece of pie as early as 1961.

Included in Oldenburg's one-man shows are always some of the studies for the exhibited objects and occasionally independent drawings, as the six colossal monument proposals in his March 1966 exhibition at the Janis Gallery. It was on this occasion that he presented the Bathroom group; and this was also the first showing of his extremely

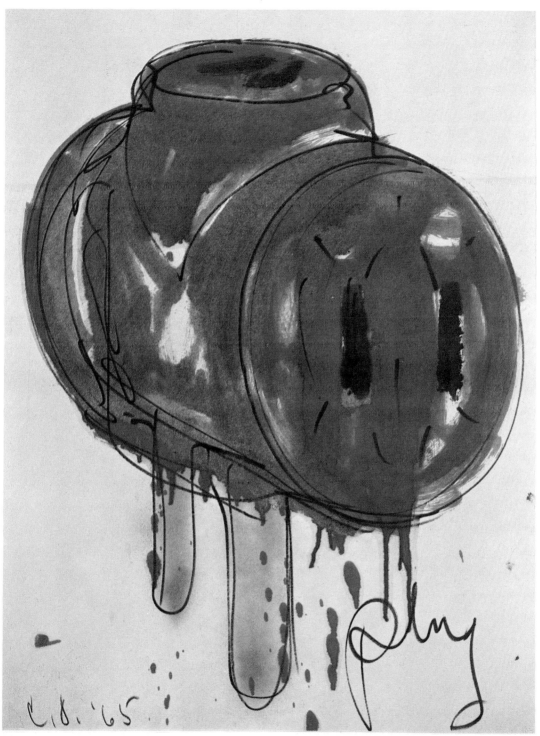

25. *Sketch of a 3-Way Plug*, 1965

ambitious project based on a 1930s Chrysler, the *Airflow*. Oldenburg made an exhaustive study of the Airflow, assembling all available photographs and other documents and visiting its designer, Carl Breer. Analyzing the 'anatomy' of the car, internal and external, he planned a vast program of Airflows and Airflow parts in six different scales, the last to be larger than the actual size of the car. He executed an enormous quantity of drawings and stencils and patterns in a variety of sizes and techniques, hard and soft models, and finished works in stencilled canvas or vinyl filled with kapok: whole cars, tires, horns, doors, engine, fan belt, oil filter, radiator. The soft pieces [27] give in to gravity and droop like a relaxed and vulnerable body. In these metamorphic sculptures, again the hard and mechanical become the soft and organic. A dismembered car is evocative enough but to present it in pliant cloth is doubly poignant. The soft *Airflow* pieces arouse a disquieting mixture of horror, sympathy, amusement — but above all delight in their hanging, variable forms, their texture, line and color. The small vinyl cars are bright, shiny and impudent; the canvas pieces are muted and restricted in color, recalling the 1959–60 *Street* constructions in their New York greys, browns and blacks, with faint touches of dusty rose, blue or green.

Among the several reasons why Oldenburg chose this particular car are: as a child he had a toy model of the Airflow; he has always admired the car's design; and, in his words, 'A certain pathos is attached to the invention which did not succeed in sales, while successful and influential as an automotive advance. A parallel to art — what is important is not usually what sells. . . . The car was conceived as a profile originally in wind tunnel tests. This is like the technique of sewing from patterns.'[49] Moreover, his choosing a 1930s car model is related to his having selected an out-of-date type of pay-telephone for his first vinyl piece, partly because in a few years, when it is completely obsolete, it will, as he says, 'appear to be a very mysterious object . . . it will have an almost abstract quality'.[50]

For similar reasons the source of his *Giant Soft Fan* [26] of 1966–7 was an old one, which is still in his studio, black, straightforward and bluntly functional in shape, with blades exposed. The impressive sculpture, ten feet high with a cord more than twenty-four feet long, was a complex work to design and execute in the stitched vinyl medium. This piece dramatically demonstrates that his sewing is drawing and his drawing is a palpable thing. The writhing form, as alive as a sleek black water-snake, threatens to snatch and enmesh the too daring observer. This is a directly physical reaction, induced by the form of the piece, whereas the threat of the original object's whirring blades is a conceptual

26. *Giant Soft Fan*, 1966–7

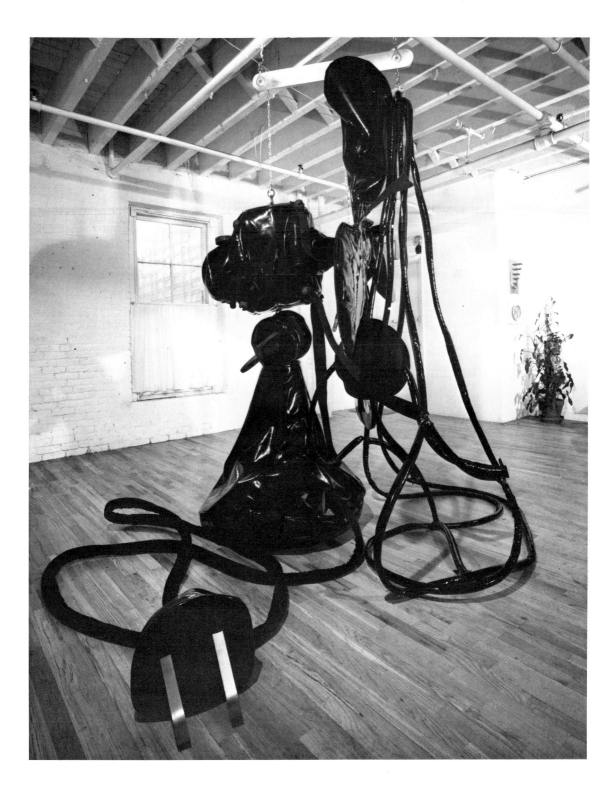

association. One takes intellectual delight in the irony of the metal fan's defeat by vinyl (Ray Gun is 'the gun that shoots but does not kill'[51]). However, the majestic *Soft Fan,* like a mysterious tribal image, inspires awe, and even terror. It *is* black magic, in spite of the fact that its power is cloaked in an elegant construction of suave material — a characteristic example of the contradiction which is a fundamental premise of Oldenburg's art and thought.

Opposing and complementing the black fan is the white canvas version, which in this instance was executed after the vinyl. In all other cases, the canvas pieces were made first (or simultaneously) as models to explore the possibilities of sewing the mobile forms in vinyl; however, material creating form, they turned out to be admirable for their own qualities: not quite so giving, more remote and austere. Oldenburg lets his mind move through a counterpoise of associations: *'Fan* means Satan in Swedish — there is that area to explore. There is a black fan and a white one —

a working of the theme of opposites in the context of superstition. I have a shiny black fan and a dry white fan — like the two angels, those winged victories that walk beside you — the white angel and the black angel. One for day, one for night; turn to the left, turn to the right. If people want to find things, they are probably there.'[52]

The thematic contradictions which engage Oldenburg are played against each other from work to work and within the single work. The soft *Drainpipes,* one red and the other blue [28], are openly sexual images as well as secular crucifixes. The slithering red vinyl version is both more 'bloody' and more voluptuous, thus more brutal in its implied mutilation than the dry *Soft Drainpipe — Blue (Cool) Version*; but when the latter is drawn up tightly on the pulley to which it is attached, it is as painful as anything in contemporary art. It is a cross for our times, but it is also a beautiful sculpture in praise of life. There are several other variations on the drainpipe theme: a straight-edged red and

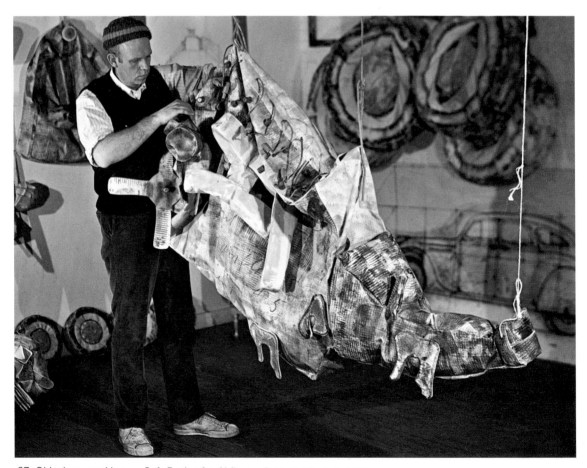

27. Oldenburg working on *Soft Engine for Airflow — Scale 5 (Model),* 1966

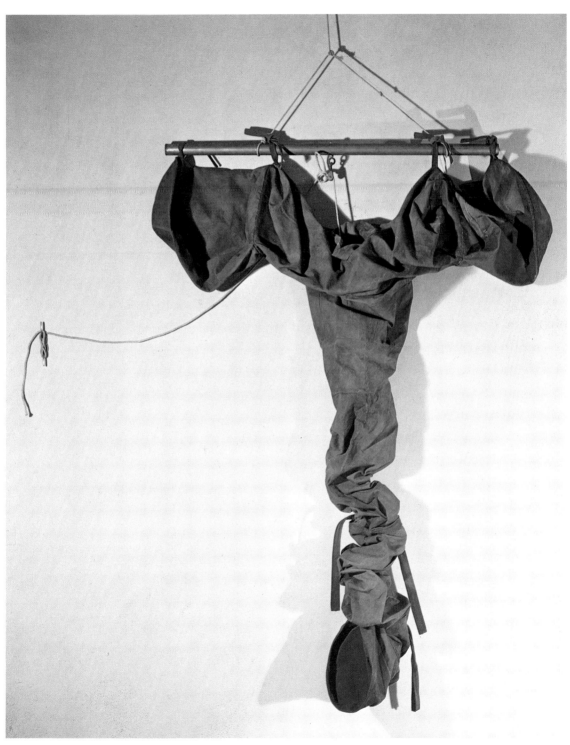

28. *Soft Drainpipe – Blue (Cool) Version*, 1967

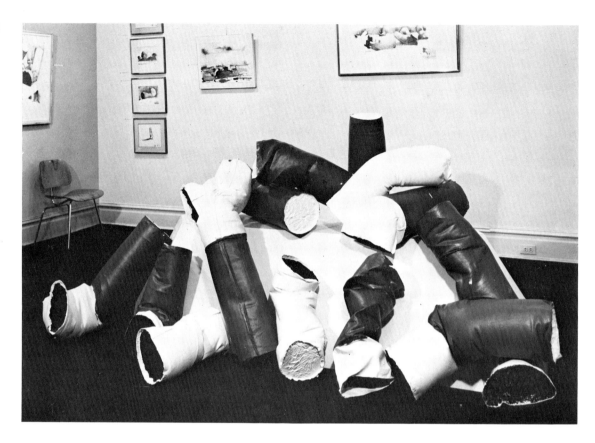

white wooden piece, an uncompromising and elegant form, and a flock of drawings and watercolors in a variety of styles. The numerous visual sources of the drainpipe motif include clippings of an actual Swedish drainpipe and two or three crucifixes (partially overpainted by the artist), and the T shape for Thure (his middle name) and for Toronto. The first drainpipe was a drawing he made for the catalog of an exhibition in Toronto.[53]

As could be expected in view of Oldenburg's complexity and his Gargantuan absorption and compiling of thoughts and images, never is a given work based on a single source. Among the multiple visual sources which figured in the genesis of his *Giant Fagends — Scale I* [29] are: a British anti-smoking poster [30], the bent flues on the roof of a building adjoining his 14th Street studio [31, 32], the cylindrical objects (pencils, paint cans, etc.) catching his eye in the studio, a photograph of cut wood stacked in a fireplace, and innumerable clippings and photographs of knees from the London notebook. (The sources for *Giant Fagends, London Knees,* and *Giant Soft Drum Set* are closely interwoven.) As his work possesses him so com-

pletely, he makes a great number of studies before, during and after the execution of a major piece. Besides many other variants of the fagends theme, there are several hand-sized assemblages of actual cigarette stubs and five or six colossal monument proposals, including one for several fagends 'to be scattered like columns of ancient temples' in Hyde Park.[54]

The mass of cylinders spilling about in *Giant Fagends — Scale 1* recalls the voluptuous piling up of curved shapes in Ingres's *Le Bain Turc* (which is difficult to look at without thinking of an overflowing ashtray) and in Delacroix's *Death of Sardanapalus.* In the Oldenburg, as in the Delacroix, eroticism is combined with violence, but the implication of shattered limbs in *Fagends* is more shocking than Delacroix's explicit representation of slaughter. In this regard, Oldenburg's piece is closer to Picasso's *Charnel House;* but it is saved from going too far in the suggestion of severed bodies[55] by its insistent existence as an almost abstract sculpture of a trivial object presented on a grand scale, and by the comic irony which Oldenburg consistently maintains as a *sine qua non* for survival.

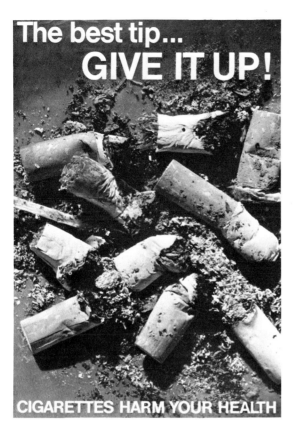

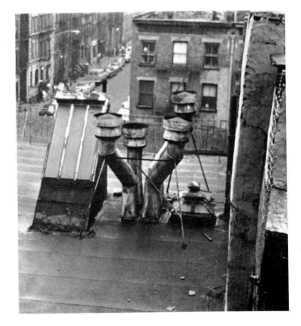

29 *(opposite). Giant Fagends — Scale I,* 1967

30. British anti-smoking poster

31. *Flues on Neighboring Roof,* 1967

32. Flues on roof neighboring Oldenburg's
14th Street studio, New York

The contradictions which are resolved in Oldenburg's work are never more apparent than in the *Lipstick on Caterpillar Tracks* [33], donated to Yale University by the artist and a group of students and faculty. Never accepted by the university and badly treated, it was removed in the summer of 1970 to be circulated on a loan basis to other campuses. An entry in Oldenburg's notebooks reads, 'The streets where revolutions have usually taken place and where monuments have usually stood . . . are not the new battleground which is the University. . . . My monuments are for intellectual consumption anyway. . . . Protest or not or what, I think monuments are better for universities (and newspapers) than for streets and corporations.'[56] The sculpture stood in an open square on a movable base ('Isn't it terrible to have sculptures littering the landscape unremovable?').[57] In its bright color, contemporary form and material, and its ignoble subject, it attacked the sterility and pretentiousness of the classicistic building behind it. As the artist has pointed out, it opposed levity to solemnity, color to colorlessness, metal to stone, simple to a sophisticated tradition.[58] In theme, it is both phallic, life-engendering, and a bomb, the harbinger of death. Male in

33. *Lipstick on Caterpillar Tracks (for Yale University)*, 1969

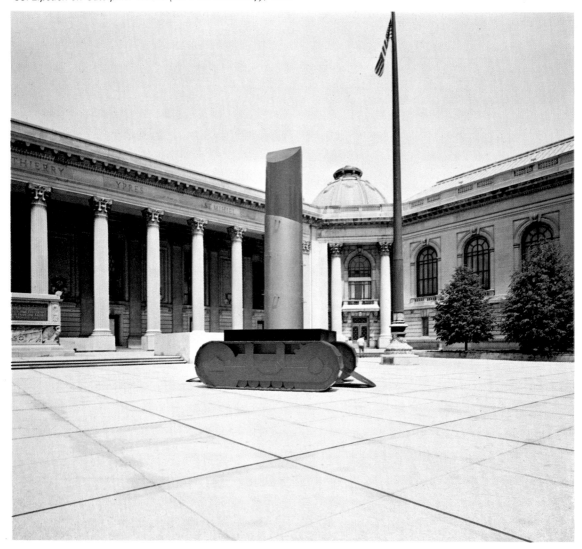

form, it is female in subject; a two-inch object carried in every woman's purse stretches twenty-four feet into the sky. This amusing conceit cloaks a sober truth — the interchangeability of life (Eros) and death.

The Lipstick motif first appeared in 1966 as a colossal monument proposal to replace the Fountain of Eros in Piccadilly Circus. The lipstick was designed to rise up out of its tube and then recede back into it, as the Thames rises and falls with the tide, which Oldenburg was always aware of in London. 'My monuments within the city are keyed to this movement, bringing the movement into the city — like

breathing on a large scale.[59] The Yale sculpture also was originally intended to ascend and descend, as is clear from the title of the maquette, *Monument for Yale University: Lipstick (Model for a Giant Traveling and Telescoping Lipstick with Changeable Parts Showing Three Stages of Extension)*.

The *Giant Icebag* [34], however, does move and even breathes. This enormous structure, made of one hundred yards of vinyl, is drawn up to a height of sixteen and a half feet as the mirror-like, reflective cap nutates and then moves from a horizontal to a vertical position. The entire cycle of movements takes twenty minutes. The elaborate

34 *Giant Icebag*, 1969 70

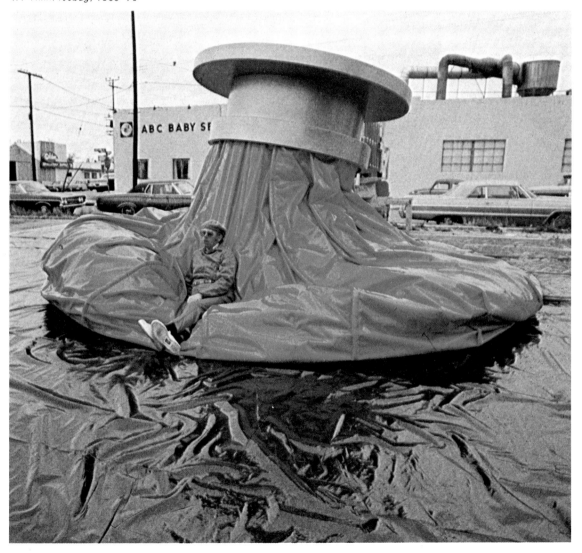

construction, designed by Oldenburg, sponsored by Gemini G. E. L. of Los Angeles, and engineered and executed for them by Krofft Enterprises, in close consultation with the artist, includes a complicated system of gears, hydraulics and blowers. It is characteristic of Oldenburg's daring that his first mechanized sculpture should be on such a vast scale and require so much of technology. However, this huge, seductive, animate sculpture owes its life less to the machines within it than to Oldenburg's power to harness his incomparable fantasy and give it form.

Formally related to such pieces as his punching bag, typewriter eraser, tea bag, and soft ash tray, the Icebag was originally designed as an outdoor sculpture for a corner site at Oberlin College[60] (where it was found unfeasible for technical reasons — traffic regulations, etc.). From the beginning, Oldenburg had planned the Icebag as a large, soft and movable monument; he soon discovered that he also wanted it to be kinetic.[61] The undulating *Giant Icebag,* exhibited at the American pavilion of Expo '70 in Osaka, is doubtless seen by some observers as an inverted atomic bomb mushroom, by many as a delightful piece for an amusement park, and by some as a witty attack on self-important monuments which 'just sit there for ever and don't do anything'. It is sure to arouse many other conflicting associations and interpretations; but it will remain an exciting example of how an inventive artist can use machinery, as he does any medium or technique, for the service of art.

Constancy of Forms

When Oldenburg's lusciously painted plaster products were first put on the market in 1961, most lay observers and many critics reacted to them as surrogates for real edibles and clothing. Unfortunately, a decade later, this response still holds in many quarters. Although Oldenburg's hamburgers and ice cream cones have become as familiar symbols of the sixties as Warhol's soup cans and Lichtenstein's comics, one still hears the comment, 'It's amusing, but is it art?' Not only the man in the street, but many art-informed individuals, including serious students and connoisseurs, are so put off by the artist's subject matter that they fail to recognize what he has done with it. They bang their heads, metaphorically speaking, so hard against the plaster ice cream cone that they blind themselves to its richly painted shifting surfaces and its decisive form. Oldenburg's aggrandizement of size continues to evoke the reaction, 'Who ever heard of a seven foot hamburger!' rather than

the realization that his manipulation of scale underlines the fact that he is inventing, not imitating. While his *Store* was based on the products and advertising layouts in real stores, the contrast between it and an actual store and actual objects is an essential part of its significance, which rests in the tension and ambiguity between art and reality, and the multiple layers of reality. His created objects are consciously related to the style of advertising images in their direct, simplified, immediately readable shapes; but they are also unmistakably works by Oldenburg and their formal consistency is his doing.

Oldenburg's objects are consonant with each other not just because they are thematically and technically similar, but because they are the products of a carefully established formal plan. For each phase of his activity, Oldenburg sets up what he calls 'rules' for himself. In painting the *Store* pieces, for example, he deliberately limited himself to seven hues (plus neutrals) of house paint enamel, and he used these colors straight, i.e. without mixing, except for the occasional addition of white, as in the raspberry sherbet colored dress. He wished to retain the brash, artificial quality of commercial advertising colors. Color was given dominance in the Store, as line and plane in the Street, and volume in the Home. Obviously these elements overlap — line, for example, plays a considerable role in the *Store* pieces — but his emphasis upon one of them in each period demonstrates his disciplined attention to formal concerns. His deliberately limited palette for the *Home* was discussed in the preceding chapter. In Provincetown in 1960, he established and followed a set of rules for making the Flags. Each had to be constructed of objects found in a different and particular location. (Each of them is named for the place where it was made, as *Cemetery Flag, Kornville Flag,* etc.) First he had to find a rectangle, then a staff, then a smaller rectangle, and finally stripes and stars. Each Flag had to be completed before time to go to work washing dishes. 'How to make use of the morning out,' he comments. 'Ritualize the play and it becomes art.'[62]

Consonance between pieces from different periods, as well as within the same one, is largely the result of Oldenburg's adherence to a few geometric forms in the basic structure of his works, all of which can be reduced to circles and rectangles (with a few triangles). As was pointed out in the analysis of the *Bedroom,* Oldenburg makes geometry tangible. He does so, as he says, by 'turning geometry into something to touch or bite into,' by 'making geometry edible'.[63] Going backwards from his very solid to plane geometry, the pink *Soft Light Switches* can be read as one large and two smaller rectangles; the *Floor-Burger* three

35. *Plug = Legs = Shoestring Potatoes*, 1966

large disks topped by a small one; the *(Giant) Ice Cream Cone* a half-circle on a triangle (which, in its three-dimensional form, Oldenburg defines as 'disks continued in space but seen in vanishing point perspective',[64] i.e. a cone). *Viandes (Meat Counter)* is composed primarily of circles extended into cylinders placed on rectangles; *Three-Way Plug* two rectangles suspended from the crossing of two cylinders; and the *Bedroom* and *Airflow Ensembles* are elaborate compositions of the basic elements.

Obviously, almost any art can be reduced to elemental geometric forms; but Oldenburg is exceptional in the obsessive attention which he gives, and the pleasure he takes, in finding and creating such similarities between otherwise unlike objects. His observations on earlier art often refer to this element; for example, in Ingres's painting, he especially enjoys the circles and ovals and the contrast between severe geometry and seductive realism.[65] In his own work, by combining, reversing and in other ways slightly varying the formal constants, Oldenburg makes objects 'rhyme' with each other as they metamorphose from one kind of being to another. 'These shapes that I like to see and their combinations are my vocabulary, or my vocabulary is these shapes and combinations (which precede the object) and the objects around me in which I find them.'[66]

Sometimes he makes quick drawings illustrating these metamorphic analogues, such as *Plug = Legs = Shoestring Potatoes* [35]; more often he simply notes the formal equivalents verbally, as, to cite just one of the innumerable examples that appear in his notes, 'soft drainpipe = bathtub = soft wingnut = faucet and handles'.

The *Ray Gun* image [2] has a special fascination for Oldenburg visually as well as psychologically and its right-angled form haunts his work. It takes many guises, among them a car, a Dormeyer mixer, a toilet, a shoe and a lamb chop. As Oldenburg's drawing [36] demonstrates, the lipstick, drainpipe and fireplug are double-handled, single-barreled ray guns. Playing the 'game' (as he refers to it) of formal analogues along with Oldenburg, one becomes ever more amazed by his wit, fantasy and inventiveness. Besides a series of drawings showing the Ray Gun lineage, he has made similar 'systems of iconography' in which another 'alter ego', the Mouse, plays a major role. Given Oldenburg's analytic mind and his disposition to classify and to order, it is hardly surprising that his studio archives contain a wealth of material on the recurrence and inter-relationship of formal motifs. Among his numerous other systematic classifications are several pages analyzing the shapes characteristic of a particular locale, such as diagrams of forms most frequently encountered in Provincetown, where

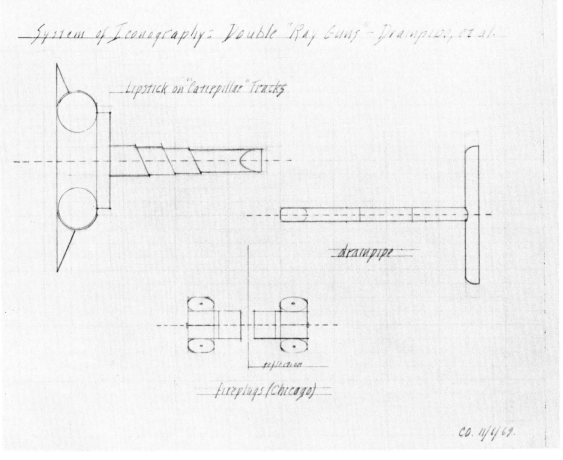

System of Iconography: Double 'Ray Guns' - Drainpipe, et al.

Lipstick on 'Catepillar' Tracks

drainpipe

replication

fireplugs (Chicago)

CO. 11/4/69.

36. *System of Iconography —*
Double 'Ray Guns' — Drainpipe, et al., 1969

he spent the summer of 1960. Oldenburg preserves all these analyses towards an 'encyclopaedia of forms'; should he ever publish such a study, it would be of inestimable value to the serious student. And it is to be hoped that it would also assist the casual observer to realize that the worth of a piece of art does not reside in its subject matter, but that its content, or meaning, depends upon the expressiveness of its form. In 1826, Goethe stated his position on this fundamental problem of art and its audience: 'The subject is immediately perceived by everyone, the content is found only by him who has something to add to it, and the form is a secret to most.'[67] And in 1962 Oldenburg wrote, 'The absence of subject matter did not help people to see the real content of a work, and I don't suppose the obvious presence of say a hamburger will either.'[68]

Tradition and Innovation

While Oldenburg's creativity has contributed directly to some of the changes in form and attitude which American sculpture has undergone in the sixties, he retains closer ties with tradition than most avant-garde sculptors do; but he does so in a unique and contradictory way. Like most Western sculpture for the past two thousand years and more, Oldenburg's still deals with the human body, but only fragments of it, and these fragments, except for a few pieces such as *Strong Arm,* are presented metaphorically, disguised as drainpipe, bathtub, fireplug, etc. In spite of its newness, his work can still be classified according to the traditional categories not only of figure, but also of landscape and still life. The point is not just that he makes pieces

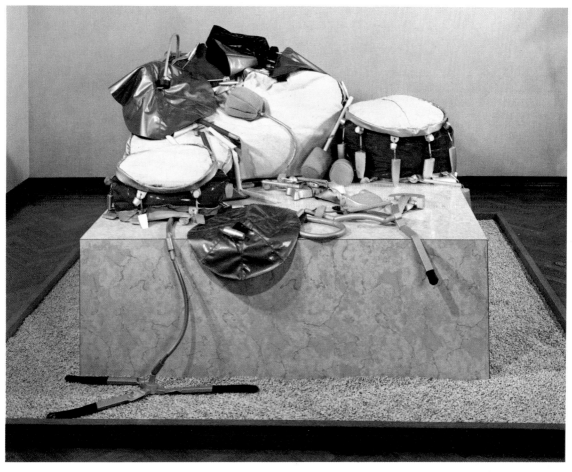

37. *Giant Soft Drum Set*, 1967

specifically in those genres, but that he works in what could be considered as figure, landscape and still-life modes which are not contingent upon subject-matter. The *Giant Soft Drum Set* [37] is a good example of the land-scape mode. It is composed of many separate and unlike parts thrusting in diverse directions and in different dis-tances from each other and, so to speak, in different scales, and in a variety of shapes, sizes, materials and textures, just as a landscape view in nature might be a mixture of hun-dred-year-old pines, maple saplings, rose bushes, violets, a cathedral, cottages, a man, a squirrel and a blue-jay. Thus, the *Giant Soft Drum Set* is intrinsically a landscape — not just because its configuration happens to resemble Cézanne's Mont-Ste-Victoire. The work is also, incident-ally, a landscape because it was affected by Oldenburg's

experience of his surroundings at Aspen, Colorado in the summer of 1967.[69] Although he had been planning the *Drum Set* for some time, its final form and character owe much to the mountain-enclosed valley at Aspen, with its spatial complexities and contradictory phenomena and conditions: open, closed; tight, loose; hard, soft; inert, mobile; serene, stormy; silent, roaring. A drum can suggest sky and the cymbals clouds to anyone; but it takes an intensely physical imagination and formal power like Oldenburg's to convey the rolling and clashing of thunder and lightning and what he calls the 'sound of sunsets' through the formal qualities which he finds and gives to multi-colored vinyl, canvas, foam rubber, wood, and chrome. Good Swede that he is, Oldenburg is 'nature-oriented . . . For leaves and trees I used cardboard. For lakes

and lagoons, vinyl.'[70] The *Giant Soft Drum Set* is further a landscape – like nature – in that all of its one hundred and twenty-five pieces want to go their own way, which Oldenburg encourages at the same time that he orders all these 'unruly' individualities, as he says, by such formal means as the repetition of the very symbol of unity, the circle. The fact that this elaborate composition is in the landscape mode does not preclude its alluding to the human figure; visceral and male and female body parts can readily be seen by anyone accustomed to looking at Oldenburg's work in that way. It is a very erotic piece. 'Drum Set is an unmade bed.'[71]

The majority of Oldenburg's sculptures are in a figural mode (as well as being metaphors for the human body or its fragments).[72] There is a closer relationship in scale and proportion between the individual parts of a figure than of a landscape, and there are no completely discrete parts in a human body, i.e. the parts are all joined by a continuous skin as they are in the *Soft Drainpipes* or *Soft Wall Switches*. The one-ness of such characteristic Oldenburg images – single, whole, immediately readable – connects his work formally with 'minimal art', or 'primary structures', which are otherwise so different from his.[73]

The still-life mode, less frequently employed by Oldenburg, falls between the landscape and figural modes. Here, as in landscape, the individual parts are distinct from each other, but there is less range and variation of distance, size and shape between them. In *Viandes (Meat Counter)* [22], for example, the repetition of similar forms (rows of like chops, piles of sausages) brings to mind another idiom of the sixties i.e. the serial or 'systemic' style. To some extent, *Viandes* could be compared with Carl André's rows of bricks or Don Judd's additive pieces. However, Judd insists that it does not matter how many, or how few exactly similar units are added one after another in his multi-partite works, whereas in Oldenburg's *Viandes* the clusters of repeated items are so placed in relation to each other that a rhythm of intervals is established. Thus, unlike Judd's, this particular piece is a 'relational' composition, although a thoroughly open and variable one.

Besides the modes, another area in which Oldenburg is somewhat traditional is his method of proceeding in working out his major pieces. He undertakes exhaustive researches (as well as accepting some things as they come to him, by chance), makes innumerable preparatory drawings of the whole and its parts, and visualizations of the work in various conditions or states; cardboard, styrofoam, canvas and other models; patterns and stencils; and occasionally more than one version of the final work. Moreover, the Street, Store and Home projects might be likened to the great programmatic cycles of the past, such as the sculptural programs decorating medieval churches or Rubens's Marie de' Medici series, for example. The differences between them, however, are so vast that it is a tenuous comparison at best.

It is in his equivocal relation to tradition that much of Oldenburg's distinct contribution rests. Aside from a few direct influences, cited earlier in this essay, and many more indirect ones (among them Duchamp[74]), and several affinities (as with Manet, Bernini and the Baroque in general), Oldenburg uses other art as he does his visual environment and his studio archives. He uses a work of art like any other object, and he subjects it to his metamorphic wit. *Brancusi's Double Ray Gun, etc.* [38] becomes a fireplug or, more accurately, joins with an actual fireplug (inverted) and with Duchamp's *Chocolate Grinder* to become a proposed fireplug monument for Chicago. In the multiple Fireplug and some of the drawings [39] in the series, Oldenburg dissolves the geometric rigidity of Brancusi's original brass or wood sculpture (there are several versions) into a more organic and drooping human torso. Brancusi's *Sleeping Muse* lies behind Oldenburg's headlight of a car (see thumb-nail sketch in illustration 38), the fallen head of Mayor Daley of Chicago, the artist's own life mask in Jello, and the huge outdoor sculpture, *Geometric Mouse I* and *Giant 3-Way Plug* for Oberlin. All of these works also allude to fallen antique heads and other architectural and sculptural fragments, as do several of the early monument proposal drawings which he made in two versions, erect and fallen. The idea of monuments tumbled down intrigues Oldenburg partly because of the romantic attitude toward ruins alluding to impermanence, disintegration, change and death, and partly because of the direct reference to the toppling over of no longer valid conventions and values. (Courbet is a romantic figure to Oldenburg largely because of the knocking-down of the column in the Place Vendôme.) The toppled sculptures are part of Oldenburg's ironical treatment of the art of the past: not only does he put earlier art into a contemporary context, but he turns it upside down – literally so in the Yale *Lipstick,* whose movable base is an inverted classic column. His inversions and rephrasings of Brancusi's sculptures, while admittedly playful, are not so much parody as homage; and there is a kinship in the way both artists transcend the specific, common subject or symbol by the force of their powerfully, but delicately, simplified forms. But, through his humor and his choice of the most banal and sometimes

38. *Brancusi's Double Ray Gun, etc.*, 1966

II. Brancusi

dontke
Ray gun
(Brancusi)

headlight
Brancusi.

parodies on sculpture
popcorn (moore)
giant - for Lincoln
Center

pipe

hinge

cinder
wear
bl. stock

large.

54 outrageously trivial subjects, Oldenburg makes it difficult for the observer to perceive that ultimate quality. His attitude toward Brancusi characterizes his attitude toward traditional art in general: while upsetting it, he respects, emulates and rejuvenates it, and extends its boundaries.

The most consequential of his contributions, considered throughout this study, is his invention of soft sewn sculpture, which altered our very conception of what sculpture is. His huge soft food objects, giant shirt and tie, piles of tires and Fagends randomly spilled or spread out on the floor, his floating Street pieces, his hanging bathtubs, drainpipes, light switches, shoestring potatoes [40], ladder, etc. — all acquiescent to gravity and other natural phenomena, all unstable and variable — anticipate a widespread sculptural mode of the late sixties, most often called 'process art'. Work in materials which have no determinate forms of their own has recently occupied several younger artists (Eva Hesse, Alan Saret, etc.) and even a master of

39. *Study of a Soft Fireplug, Inverted*, 1969

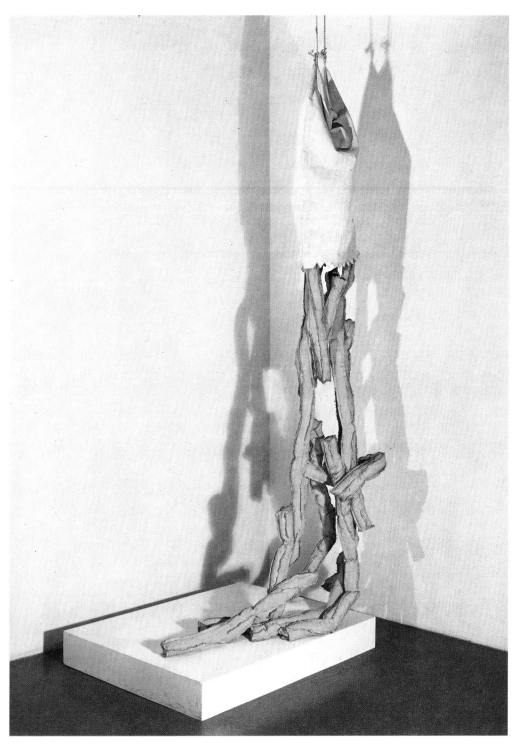

40. *Shoestring Potatoes Spilling from a Bag,* 1965–6

minimal art, Robert Morris. For his hanging felt pieces and floor works of earth, peat moss, grease, metal scraps, felt, string, etc., Morris prefers the designation 'non-constructed' since, he says, he started to work in that way because he 'wanted to do something which was not about construction as the other work was'.[75] Although Morris had made hanging-rope pieces in 1963 and 1964, and although there were isolated earlier examples of somewhat similar work (as documented in the Sidney Janis Gallery's *String and Rope* exhibition, January 1970), Oldenburg's concentration on the phenomenon of softness, beginning in 1963, and his presentation of it on such a complex scale, opened wide the dikes to related and contributory currents. It is quite possible that contemporary painting also owes something to Oldenburg's flexible sculpture; the hanging, dipping, unstretched canvases of such artists as Sam Gilliam, for example, suggest that Oldenburg's limp canvas and vinyl pieces were among their progenitors. Variability already appeared in some of Oldenburg's Store pieces, such as *Toast* of 1961 and *Pancakes and Sausages* of 1962, which are made up of several completely separated units subject to multiple and varied distribution.

In an earlier section, the *Floor-Burger* [13] of 1962 was referred to as 'just sitting there' in contrast to the mobility of his subsequent soft sculpture. However, that very quality of 'just sitting there' was a dominant and desired feature of much of the 1960s sculpture, again bringing Oldenburg into direct relationship with the minimalists. As early as 1960 Oldenburg had noted, 'Another characteristic: my concentration into a single image or form, not a larger "composition"'[76] which, as we have seen, became a basic principle of 'non-relational', minimal art. The intention here is not to credit Oldenburg with 'inventing' that mode (in any case, several pre-1960 examples of a similar kind of forming could be cited, including much of the work of the American painter Georgia O'Keeffe), but to demonstrate the wide range of his work and thought in the avant-garde of the decade.

Oldenburg is a man of his time and inevitably his work reflects ideas that are current among his contemporaries. In growing distaste for the merchandising aspects of art and finding the production of unique hand-made objects to be boring and anachronistic in our time (two reactions which have had a considerable history in modern art), many artists are turning out more multiples, having works produced in factories, and moving away from the indoor gallery situation to vast projects in the farthest reaches of the land — and sea and sky.

Oldenburg's contribution to the New York *Sculptures in Environment* festival in the fall of 1967 was an early 'earthwork', as the type of activity described above is often called. He hired gravediggers to dig a hole in Central Park; nothing was buried in the grave but the earth which had been taken from it.[77] It is tempting to quote in their entirety his illuminating notes on the 'Burial Monument', but the following will have to suffice in the present context: 'Earth, like water or air, is a spatial element in which sculpture may exist. I am very concerned with a kind of useful function of fantasy, which I think will become increasingly significant. . . . Invisibility as a medium in the most concrete of arts — sculpture. Out of sight but not out of mind. Secrecy is necessary — the piece must never be found. It must remain imaginary.'[78] Besides its relevance to earth art, this passage (and the monument itself) documents Oldenburg's pioneer thinking in the related field of invisible art and conceptual art, which also attracted many artists at the end of the decade. This is not the only reference to invisible works in Oldenburg's notebooks; but significantly, even in that vein, all of his proposals are *formed* in his mind, just as the earth piece in Central Park was conceived and executed in a specific shape, 6 x 6 x 3 feet, besides being a work as an act. He gives much leeway to chance, but he always remains the director, and he does so as a visual artist. His demand for secrecy is also noteworthy in the passage quoted above; in his view, to hold mystery and magic is a central function of art. And finally, 'It must remain imaginary'. Was that not the meaning of his colossal monument proposals?

However, Oldenburg is unique in the extent to which he has given form to his colossal imagination. He weds fantasy with fact, and has done so since he was a child and invented a whole country, Neubern. He executed precise maps, plans and other colored drawings of its thirty-six states and their principal cities, its industries, products, topology, temperature ranges, transportation systems, with beautifully designed and colored trains, planes and ships, and their insignia. He peopled his land, gave it a history of rulers from John Boule in 1436 to Claes Oldenburg in 1935; provided its cities with airports [41], stadiums,. parks; published books, magazines, comics and newspapers (in English or Swedish or both); and offered a lively program of films and theater pieces. One is of course reminded of the Brontë juvenilia, the more so since Oldenburg's younger brother, Richard — and even his father[79] — took part in the project, each having his own imaginary land. Nobbeberg, Mr Oldenburg's country, was an evil one, as is expressed in the very shape which the boy Claes gave to it in his drawing [42] showing the territorial and population changes of Nobbeberg and Neubern from 1436 to 1939. In 1939 he was ten years old; most of the Neubern inventions are earlier. The whole Neubern material is an astonishing

41 *(below). Rex Airport, Neubern, c.* 1939

42. *Neubern vs. Nobbeberg 1430–1939,* 1939

prefiguration of the mature artist's boundless imagination and his ability to give actuality to his vision, and to share it with us, through his disciplined and touching forms.

Oldenburg is fully aware that 'A characteristic of modern structure (and life, order) is the disappearance of form as motive'. He continues, 'contradictory in my work (maybe) is the reflection of this tendency . . . to a-form.'[80] While that may be so, he still holds that 'To give birth to form is the only act of man that has any consequence. This act, which I call art, may take so many shapes, as yet undignified by that very dignified name. And in the strict sense, is drawing, which may be defined as the accidental ability to coordinate your fantasy with your hand.'[81] Oldenburg's 'accidental ability' is a supreme gift, which no contemporary artist has worked harder to deserve and to repay.

(Statements by Oldenburg taken from his notebooks and other studio archives are referred to as *Notes*.)

1 *Notes*, 1961, published in Oldenburg's *Store Days*, p. 113. **2** ibid., p. 49. **3** *Notes*, 1966. **4** Quoted in the news release announcing the exhibition and in the catalog, which is in the form of a record. **5** *Notes*, 1955, 'Painting and theorizing, all activities — are they rationalizations for narcissistic obsession?' **6** Conversation with the author, September 1969. In reply to a question regarding Norman Brown's significance for him, Oldenburg wrote, 'Billy Klüver introduced me to Norman Brown's first book [*Life Against Death*, Middletown, Connecticut, 1959]. However, it is in the line of neo-Freudian readings which for me seems built on D. H. Lawrence's *Studies in Classic American Literature*, Gershon Legman's studies (e.g. *Love and Death* about mass media in USA which I read in college) and Leslie Fielder. Neo-Freudian analysis of American tradition is reflected in *Injun* — the pamphlet, and much of the Ray Gun Theater, esp. *Fotodeath*. The title comes from an account of a mass murderer who always photographed his victims in the desert before killing them — equated with Death by light — the H bomb. . . . Brown's rereading of Swift interested me especially.' Letter to the author, August 1969. **7** At the special opening, 23 September 1969, of his retrospective exhibition Oldenburg touchingly acknowledged his indebtedness to these and other early friends. This was commented upon by Camille Gordon in the *Something Else Newsletter*, November 1969: 'The old saws about fame bringing ungraciousness don't seem to apply to the really great ones. What with his triumph at New York's Museum of Modern Art, and the New York papers describing the 1960s as "The Oldenburg Decade," Claes might have been excused if he had seemed a bit preoccupied. But no. Instead he invited to the opening all the artists he could think of who had worked with him in his salad days, performers from his Happenings, old friends from the Lower East Side or Chicago, to come join him. And come they did, by the thousands. Has the dear old MOMA ever had such a happy crowd? Not a sign of pickets, which should be a lesson to them. And then too, there was Oldenburg's speech at dinner. Just a few words, mentioning his debt to his old Reuben Gallery colleagues— Kaprow, Grooms, Whitman and the rest. It was beautiful.' **8** Actually he had exhibited in New York prior to this first major show of constructions: in December 1958, drawings in a group show at Red Grooms's City Gallery and in March 1959, a one-man show of drawings at the Cooper Union Art School Library. **9** *The Elephant Mask*, begun in 1957, was made in the print-shop studio of his friend Richard O. Tyler, who was deeply interested in magic and mysticism. Oldenburg says that this 'modern alchemist', as Tyler considered himself, 'introduced me to the irrational'. **10** The antagonism between 'blood knowledge' or 'blood consciousness' and 'mind-consciousness' which 'is our cross' is a basic theme of D. H. Lawrence's *Studies in Classic American Literature*, New York, 1923, which Oldenburg read with pleasure and profit. **11** *Notes*, 1969. In a typescript of 'Chronology, Notes and Essay on my Drawing', which Oldenburg prepared for use in the *Drawings and Prints* publication, the following entry appears under 1959: 'The style changes radically after the summer into one

derived from the subject, angular, crude, symbolic. The change was influenced by the example of Dubuffet and by reading *Mort à Crédit* by Céline — which is the explanation of the drawing containing their names. . . . More direct influences were the drawings of Red Grooms and Jim Dine. I sought a crudity in style to match the crudity of my surroundings in the poor area of NYC.' **12** The phrase 'The Living Object', which I used as the title of an article on Oldenburg's *Store, Art International*, January 1963, characterizes the work of the entire decade. **13** *Notes*, 1969, in 'Essay on my Drawing', under 1959, cf. n. 11 above. **14** Shown concurrently with Oldenburg's *The Street* was Jim Dine's *The Home*. Dine was one of the original members of the Judson Gallery group. In a statement written 3 April 1970, Oldenburg clarified their collaboration in the 'Ray Gun' show: *As I remember it, Jim Dine was something less than an enthusiastic collaborator, which I found understandable. I imposed my idea for a show on him, I set out the area I wanted him to work in — by building dividers in the gallery, and I designated his area 'The Home' and mine 'The Street.' I described his as a 'female' area, mine as a 'male' one. I presumed to inform him that an enclosure, a uterus-like form would better suit his expression, and in other ways leaned on him. I am surprised in retrospect that he tolerated my directions, but he did help and in a few hectic, obsessive days, responded with his interior environment; days, I recall, when his wife Nancy was out of town. As soon as she returned, he disappeared from the gallery and the 'collaboration.' During the construction I would 'feed' Dine — literally, by shoving debris I had gathered from the streets into the opening of his room. In the morning, he found fresh material. In thinking back, I imagine Jim might have been fighting himself free of just the sort of expression I was asking of him. I remember vividly a visit with him to Kaprow's house in New Jersey in 1961, when the sight of Kaprow's 'garage environment' caused Jim to become ill and go home. I suppose I had analysed and exploited Jim's obsessiveness in a characteristically cruel way, as I might later encourage the obsession of a player in my 'happenings.' The accumulations rage was always easy to stimulate — it fills both space and time, without decision, without direction. It is an image of consumption and of American life.* **15** *Notes, 1960*. **16** *Notes*, 1961, published in *Store Days*, p. 49. **17** *Notes*, 1969. From 'Essay on my Drawing' under 1960, cf. n. 11. **18** loc. cit. **19** ibid., under 1961.

20 *Notes*, 1961, published in the Martha Jackson catalog and, in a slightly different and longer form, in *Store Days*, pp. 39–42. **21** *Notes*, 1961, published in *Store Days*, p. 15. **22** loc. cit. **23** In a letter to the author, 6 November 1969, Oldenburg refers to his 'Scrap method of ordering material. General rule of mosaic of fragments to depict experience.' **24** Since making this comparison, I have learned from Oldenburg that the Parthenon figure was indeed an actual source of *Girls' Dresses Blowing in the Wind* — an example of his rephrasing of earlier art, which will be taken up later in this study. **25** From a letter to the author, August 1969. **26** 'Extracts from the Studio Notes (1962–64)', *Art Forum*, January 1966, p. 33. **27** Oldenburg tends to prefer the designation 'performance' to 'happening', but the latter has more common usage. **28** From 'Store Days II' script in *Store Days*, p. 122. **29** *Store Days*, p. 83.

30 loc. cit. **31** Oldenburg was excluded as being a sculptor not a painter. **32** *Store Days,* p. 110. **33** Oldenburg's treatment of scale – exaggerating down as well as up – is often referred to as 'Lilliputian to Brobdingnagian'. The reference is more apt than some critics realize; Oldenburg frequently alludes to Swift, especially *Gulliver's Travels,* in his notes. For the introduction to the catalog of his 1967 show at the Janis Gallery, Oldenburg selected an apt passage from 'Gulliver in Laputa'. **34** From a letter to the author, August 1969. **35** loc. cit. **36** From a letter to the author, November 1969. **37** Oldenburg recounts the difficulties encountered in constructing the replica in his article, 'The bedroom ensemble, replica I', *Studio International,* July-August 1969. **38** *'On the Rationalization of Sight'* is the title of a book on perspective by William M. Ivins, Jr, New York, 1938. **39** The designer John Kloss made a black vinyl dress with pink lining for Pat Oldenburg in late 1962.

40 Discussion with Lichtenstein and Warhol, moderated by Bruce Glaser, broadcast on WBAI, New York, June 1964, published in *Artforum,* February 1966, pp. 20–24 (22). **41** Oldenburg, *Proposals for Monuments and Buildings,* p. 15. **42** ibid., p. 156. **43** ibid., p. 16. **44** *Notes,* Lecture, November 1966 at Bath Academy of Art, Corsham, Wiltshire. A further explanation of the teddy bear's significance may be found in *Monuments,* p. 15. **45** *Notes,* 1967, New York. **46** *Monuments,* p. 12. **47** ibid., p. 19. **48** Illustrated in *Monuments,* p. 69. **49** *Notes,* 1965–6, New York.

50 *Notes,* 1968. From a lecture delivered at the Art Institute of Chicago, 1968. **51** *Notes,* 1966. **52** *Monuments,* p. 162. **53** *Dine Oldenburg Segal,* (exhibition catalog) Art Gallery of Ontario, Toronto, 14 January–12 February 1967 and Albright-Knox Art Gallery, Buffalo, 24 February – 26 March 1967, facing p. 32. **54** *Some Program Notes about Monuments, Mainly,* Supplement to catalog of Oldenburg exhibition at Sidney Janis Gallery, 26 April –27 May 1967 (published in *Chelsea,* no. 22–3, June 1968, pp. 87–92.) **55** That Oldenburg was aware of this hazard (and also of some of the analogies suggested in this paragraph) is testified to in the following passage from his notes, 'Fagends faced the danger of becoming garbage of a torture chamber, also that of coming to rest as the twined limbs and tails of an Ingres orgy, Rubensian asstray . . . The show came out intensely lyric, as it should be . . . The joy of this show is that I assimilated, translated, say maybe transcended my undoubted obscenity but also the twice obscene, twice monstrous infinitely gorgeous horrors of the times.' *Notes,* 1966–7, published in Claes Oldenburg, 'America: War and Sex, Etc.' *Arts Magazine,* Summer 1967, p. 38. He specifically notes, 'Fagends equal the P's *Charnel House,*' ibid., p. 34. **56** *Notes,* 1969. **57** loc. cit. **58** In a letter to the author, August 1969. **59** *Monuments,* p. 22.

60 Having accepted a commission for the first 'feasible' monument in January 1969, Oldenburg visited the Oberlin campus in February to select a site and consider possibilities for it. From Ohio he went on to Chicago. In his March notes appears this entry, 'Icebag it was cold – and after experience of ice – the refrigerator door to Lake Michigan.' The first scale *Model for a Giant Ice Bag on a Corner Site,* shown in the Sidney Janis Gallery group exhibition in May 1969, is in the Edwin A. Bergman collection, Chicago. (From several ideas for the Oberlin site, a *Giant 3-Way Plug* was finally decided upon and installed 10 August 1970.) **61** As his plans for the Icebag became increasingly complex, he decided that it would be an appropriate piece for his project in the Art and Technology program, whereby several artists had

been invited to work with industries in the production of ambitious designs. (This large-scale program was organized by Maurice Tuchman of the Los Angeles County Museum, where the resultant art works will be shown in the summer of 1971; eight of them were on view at Expo '70, Osaka.) Oldenburg's project was to have been executed at the Walt Disney workshops, but it was rejected by them on the grounds of being too expensive, and its sponsorship was taken over by the intrepid Gemini G. E. L., publishers of prints and multiple objects. Gemini hopes eventually to make a total of five *Giant Icebags* ('all weather' sculptures); it is the first of these which has gone to Japan. An edition of seventy-five three-foot *Icebag* multiples is now (April 1970) under production. Also available from Gemini is a sparkling film, *Sort of a commercial for an icebag,* which Oldenburg made in 1969 with Eric Saarinen as cinematographer and Michael Hugo as director. **62** Conversation with the author, 3 April 1970. **63** cf. n. 62. **64** *Notes,* 1966, Oldenburg's original typescript, in English, for his *'Eftertankar'* ('Afterthoughts'), published in *Konstrevy,* XLII, 5–6, 1966, an analysis, accompanied by drawings, of the formal constancy among works exhibited in the Stockholm Moderna Museet retrospective, 1966. **65** Conversation, September 1969. **66** *Notes,* 1964, Paris. **67** *'Den Stoff sieht jedermann vor sich, den Gehalt findet nur der, der etwas dazu zu tun het, und die Form ist ein Geheimnis den meisten.' Goethes Werke,* herausgegeben von Robert Petsch . . . Leipzig, 1926, p. 266 (in 'Maximen und Reflexionen'), first published in *Über Kunst und Altertum,* V, 3, 1826. **68** From catalog of exhibition, 'Art 1963 – A New Vocabulary', at the YM/YWHA, Philadelphia, 25 October– 7 November 1962, n.p. **69** That the *Drum Set* is a landscape is explicitly stated in the notes, as well as being documented by numerous sketches in the Aspen pages. It was consciously composed in that mode, 'I was also impressed by the Brueghel print illustrating the parable "Big Fish Eat little Fish," the scale relation of the big hollow drum to the littler drums and subordinate parts.'

70 *Notes,* 1968, New York. **71** *Notes,* 1967. **72** Oldenburg wryly comments, 'Basically, collectors want nudes. So I have supplied for them, nude cars, nude telephones, nude electric plugs, nude switches, nude fans, nude electrectera and sew on.', in 'America: War & Sex, Etc.' *Arts Magazine,* Summer 1967, p. 36. **73** Robert Morris, in discussing the shift away from minimal sculpture to 'accumulations of things or stuff, sometimes very heterogeneous' considers the former to constitute a figure-ground perceptual relationship and the latter to be a result of peripheral vision. He writes, 'In another era, one might have said that the difference was between a figurative and landscape mode,' in 'Notes on Sculpture, Part 4, Beyond Objects', *Artforum,* April 1969, p. 51. **74** In his London *Notes,* 1966, Oldenburg wrote, 'Duchamp is brilliant; he has stood the world on its end. By not making art he has made more art much more than we shall ever need.' **75** Morris in conversation with the author, March 1970. **76** *Notes,* 1960, New York. **77** See also his *Proposed Underground Memorial for President John F. Kennedy,* 1965, *Monuments,* pl. 54. 'Nothing is visible on the surface except the men tending the grass and the line of sightseers waiting to peer down through the hole.', p. 167; and the *Proposed Underground Monument – Drainpipe,* 1967, illustrated in *Drawings and Prints,* p. 197. **78** *Notes,* 1967, New York. **79** When Oldenburg père was a child, his family had constructed a miniature village, including a railway, on their estate in the Stockholm archipelago. Claes never saw the actual village, only newspaper accounts and clippings of it. The house no longer exists. **80** *Notes,* 1969. **81** *Notes,* 1967, New York.

NB: The following bibliography, arranged chronologically, is a selective one. A comprehensive bibliography appears in Barbara Rose, *Claes Oldenburg,* New York, Museum of Modern Art, 1970.

By the artist

'I am for an art . . .', in *Environments, Situations, Spaces,* (exhibition catalog) Martha Jackson Gallery, New York, 1961. Reprinted in longer form in *Store Days,* pp. 39–42.

A statement and scripts for 'Injun', 'World's Fair II', 'Gayety' and 'Autobodys' in Michael Kirby, *Happenings,* New York, 1965.

Injun and Other Histories (1960), New York, Something Else Press, 1966.

'Eftertankar' ('Afterthoughts'), *Konstrevy,* vol. XLII, no. 5–6, 1966, pp. 214–20. Appears in the original English version in Barbara Rose, *Claes Oldenburg,* New York, 1970.

'Extracts from the Studio Notes (1962–4)' *Artforum,* vol. IV, no. 5, January 1966, pp. 32–3.

'Oldenburg Lichtenstein Warhol: A Discussion' (radio broadcast, 1964) *Artforum,* vol. IV, no. 6, February 1966, pp. 21–4.

Commentary in *Claes Oldenburg Skulpturer och teckningar* (exhibition catalog) Moderna Museet, Stockholm, 1966. (Rewritten selections from 1965–6 Notes plus some new material.)

'Climbing Mt. Oldenburg' by Harris Rosenstein (based on a 1964 interview), *Art News,* vol. 64, no. 10, February 1966, pp. 22–5, 56–9.

Excerpts from the Notes in *New Work by Oldenburg,* exhibition catalog, Sidney Janis Gallery, New York 1966.

'Egomessages about Pollock' in 'Jackson Pollock: An Artists' Symposium, Part 2' *Art News,* vol. 66, no. 3, May 1967, pp. 27, 66–7.

Store Days, Documents from the Store (1961) and Ray Gun Theater (1962), selected by Claes Oldenburg and Emmett Williams, New York, Something Else Press, 1967.

'America: War & Sex, Etc.', from the Notes, *Arts Magazine,* vol. 41, no. 8, Summer 1967, pp. 32–8.

On *The Bedroom* in *São Paulo 9: United States of America.* Washington D. C. 1967, pp. 92–3.

'Take a Cigarette Butt and Make it Heroic', (interview with Suzi Gablik) *Art News,* vol. 66, no. 3, May 1967, pp. 30–31, 77.

Claes Oldenburg Notes, portfolio of lithographs based on notebook sketches, accompanied by notes, Los Angeles, Gemini G. E. L., 1968.

Proposals for Monuments and Buildings, Chicago, Big Table Publishing Company, 1969.

'The Artist Speaks: Claes Oldenburg' (Interview with John Coplans) *Art in America,* vol. 57, no. 2, March-April, 1969, pp. 68–75.

'The Bedroom Ensemble, replica I' *Studio International,* vol. 178, no. 913, July-August, 1969, pp. 2–3.

Claes Oldenburg Constructions, models and drawings, text (rewritten from Notes) for exhibition catalog, Richard Feigen Gallery, Chicago, 1969.

'My Very Last Happening . . . The Typewriter', *Esquire,* vol. LXXI, no. 5, May 1969, pp. 154–7.

'The Master of the Soft Touch' (includes Oldenburg comments), *Life,* vol. 67, no. 21, 21 November 1969, pp. 58–64.

'How to Keep Sculpture Alive In and Out of a Museum', (interview with Jeanne Siegel), *Arts Magazine,* vol. 44, no. 1, September/October 1969, pp. 24–8.

'Items toward an introduction', *Claes Oldenburg,* Arts Council of Great Britain, Tate Gallery, London, 1970.

'Chronology of drawings', *Studio International,* vol. 179, no. 923, pp. 249–52.

On Oldenburg

Tillim, Sidney, on *The Store* in 'Month in Review' *Arts Magazine,* vol. 36, no. 5, February 1962, pp. 34–7.

Johnson, Ellen H., 'The Living Object, *Art International,* vol. VII, no. 1, January 1963, pp. 42–5.

Bourdon, David, Jr, 'Claes Oldenburg', *Konstrevy,* vol. XL, no. 5–6, 1964, pp. 164–9.

Judd, Don, 'Specific Objects', *Arts Yearbook 8,* 1965, pp. 74–82.

Restany, Pierre, *'Une personalité-charnière de l'art américain: Claes Oldenburg, premières oeuvres',* Metro 9, 1965, pp. 20–26.

Baro, Gene, 'Claes Oldenburg, or the Things of this World', *Art International,* vol. X, no. 9, November 1966, pp. 41–3.

Linde, Ulf, 'Claes Oldenburg, Two Contrasting Viewpoints', and Oyvind Fahlstrom, 'Object Making', *Studio International,* vol. 172, no. 884, December 1966, pp. 326–9.

Reichardt, Jasia, 'Bridges and Oldenburgs', *Studio International,* vol. 173, no. 885, January 1967, pp. 2–3.

Johnson, Ellen H., 'Claes Oldenburg', *Dine Oldenburg Segal* (exhibition catalog) Art Gallery of Ontario, Toronto, and Albright-Knox Art Gallery, Buffalo, 1967. pp. 35–8.

Kozloff, Max, 'The Poetics of Softness', *American Sculpture of the Sixties,* exhibition catalog, Los Angeles County Museum of Art, 1967, pp. 26–30. Reprinted in his *Renderings,* New York, Simon and Schuster, 1968, pp. 223–35.

Rose, Barbara, 'Claes Oldenburg's Soft Machines', *Artforum,* vol. V, no. 10, Summer 1967, pp. 30–35.

Sylvester, David, 'The Soft Machines of Claes Oldenburg', *Vogue,* U.S. ed., February 1968, pp. 166–9, 209–12. A revised version appeared in *Sunday Times* magazine, July 1970, under title 'Furry Lollies and Soft Machines'.

Rose, Barbara, 'Oldenburg Joins the Revolution', *New York,* June 1969, pp. 54–7.

Baro, Gene, *Claes Oldenburg, Drawings and Prints,* Introduction and Commentary, New York, Chelsea House Publishers, 1969.

Finch, Christopher, 'Notes for a Monument to Claes Oldenburg', *Art News,* vol. 68, no. 6, October 1969, pp. 52–6.

Legg, Alicia, *Checklist for the Exhibition Claes Oldenburg,* Museum of Modern Art, New York 1969.

Bourgeois, Jean-Louis, 'Claes Oldenburg', (review of MOMA retrospective), *Artforum,* vol. VIII, no. 3, November 1969, pp. 75–6.

Rose, Barbara, 'The Origins, Life and Times of Ray Gun', *Artforum,* November 1969, vol. VIII, no. 3, pp. 50–57.

Rosenberg, Harold, 'The Art World; Marilyn Mondrian', *The New Yorker,* November 1969, pp. 167–76 (specifically on Oldenburg MOMA retrospective, pp. 174–6).

Schjeldahl, Peter, on MOMA retrospective, in 'New York', *Art International,* vol. XIII, no. 9, November 1969, pp. 69–70.

Rose, Barbara, *Claes Oldenburg,* New York, Museum of Modern Art, 1970.

Johnson, Ellen H., 'Oldenburg's Poetics: Analogues, Metamorphoses and Sources', *Art International,* vol. XIV, no. 4, April 1970, pp. 42–5, 51.

Johnson, Ellen H., 'Oldenburg's Giant 3-way Plug', *Arts Magazine,* vol. 45, no. 3, December 1970–January 1971, pp. 43–5.

1 Oldenburg painting *The Store* reliefs, 1961 (photo: Robert R. McElroy).

2 *Empire (Papa) Ray Gun,* 1959. Newspaper (soaked in wheat paste) over wire frame, painted with casein. $40\frac{3}{8}$ x $39\frac{3}{4}$ x $13\frac{1}{2}$ ins. Owned by the artist (photo: Nathan Rabin).

3 *Car on a Fragment of Street,* 1960. Cardboard, oil wash, spray enamel. $13\frac{1}{2}$ x $31\frac{1}{2}$ ins. Owned by the artist (photo: Eric Pollitzer).

4 *The Street II,* Reuben Gallery, 6–19 May 1960 (photo Charles Rappaport).

5 *The Street I,* in 'Ray Gun' show, Judson Gallery, 30 January–17 March 1960 (photo: the artist).

6 *Store Days I,* at Ray Gun Theater, 1962 (photo: Robert R. McElroy).

7 *Girls' Dresses Blowing in the Wind,* 1961. Enamel paint on plaster-soaked muslin, over wire frame, 42 x 41 x $6\frac{1}{2}$ ins. Collection: Mrs Claes Oldenburg (photo: Stedelijk Museum).

8 Orchard Street, New York City (photo: the author).

9 Figure of Hebe from Parthenon pediment, Elgin marbles, British Museum (photo: The British Museum).

10 *Upside Down City,* prop from *World's Fair II,* at Ray Gun Theater, 1962 (photo: William Judson III).

11 *The Store,* December 1961 (photo: Robert R. McElroy).

12 *(Giant) Ice Cream Cone,* 1962. Enamel paint on plaster-soaked muslin over wire frame. $13\frac{3}{8}$ x $37\frac{1}{2}$ x $13\frac{1}{4}$ ins. Collection: Mr and Mrs Michael Sonnabend, Paris (photo: Eric Pollitzer).

13 *Floor-Burger,* 1962. Canvas filled with foam rubber and paper cartons, painted with liquitex and latex. 52 x 84 ins. Collection: Art Gallery of Ontario, Toronto (photo: Robert R. McElroy).

14 *Electric Outlet with Plug.* 1964. Painted wood. $47\frac{1}{2}$ x $28\frac{5}{8}$ x 6 ins; plug 7 x 15 x 11 ins. Collection: Mr and Mrs Richard H. Solomon, New York (photo: Sidney Janis Gallery, New York).

15 *Bedroom Ensemble,* 1963. Wood, vinyl, metal, fake fur, etc. 10 x 17 x 21 feet. Sidney Janis Gallery, New York (photo: Eric Pollitzer).

16 *Soft Typewriter,* 1963. Vinyl, kapok, muslin, plexiglas. 27 x 26 x 9 ins. Collection: Alan R. Power, Richmond, Surrey (photo: Sidney Janis Gallery, New York).

17 *Tub (Hard Model),* 1966. Corrugated cardboard, wood, enamel paint. 80 x $32\frac{1}{2}$ x $27\frac{1}{2}$ ins. Collection: Mrs Claes Oldenburg (photo: Nathan Rabin).

18 *Soft Tub – 'Ghost' Version, 1966.* Canvas, kapok, wood, liquitex. 80 x 30 x 30 ins. Collection: Dr and Mrs Sydney L. Wax, Downsview, Ontario (photo: Geoffrey Clements).

19 *Soft Bathtub,* 1966 (Destroyed by fire, 24 December 1969). Vinyl, polyurethane, liquitex, wood, rubber. 80 x 30 x 30 ins. Collection: Mr and Mrs Roger Davidson, Toronto (photo: Eric Pollitzer).

20 *Four Soft Dormeyer Mixers – 'Ghost' Version,* 1965 Canvas, kapok, sprayed enamel, wood, 42 x 36 x 24 ins. Collection: Mr and Mrs Eugene M. Schwartz, New York (photo: Geoffrey Clements).

21 *Soft Light Switches,* 1964. Vinyl, kapok, canvas. $47\frac{1}{4}$ x $47\frac{1}{4}$ x 11 ins. Collection: William Rockhill Nelson Gallery of Art, Kansas City. Gift of the Chapin family in memory of Susan Chapin Buckwalter (photo: Nelson Gallery).

22 *Viandes (Meat Counter),* 1964. Plaster, tempera, porcelain, marble. 37 x 37 x 16 ins. Collection: Dr Hubert Peeters, Bruges (photo: Eric Pollitzer).

23 *Proposed Colossal Monument for Lower East Side: Ironing Board,* 1965. Crayon and watercolor, $21\frac{3}{4}$ x $29\frac{1}{2}$ ins. Collection: Mr and Mrs Marvin Goodman, Toronto (Barbara Goodman Trust, Stephen Goodman Trust) (photo: Geoffrey Clements).

24 *Proposed Colossal Monument for Thames River: Thames Ball (View from Below),* 1966. Crayon and watercolor. 15 x 22 ins. Collection: Neil A. Levine, New Haven, Connecticut.

25 *Sketch of a 3-Way Plug,* 1965. Crayon and oil wash. $30\frac{1}{2}$ x 23 ins. Collection: Samuel J. Wagstaff, Jr, Detroit (photo: Eric Pollitzer).

26 *Giant Soft Fan,* 1966–7. Vinyl, foam rubber, wood, metal, plastic tubing. 120 x $58\frac{5}{8}$ x $61\frac{7}{8}$ ins.; cord and plug $291\frac{1}{4}$ ins. The Museum of Modern Art, New York. (The Sidney and Harriet Janis Collection) (photo: Sidney Janis Gallery, New York)

27 Oldenburg working on *Soft Engine for Airflow – Scale 5 (Model),* 1966. Canvas, kapok, sprayed enamel, rope, wood. $53\frac{1}{8}$ x $71\frac{7}{8}$ x $17\frac{3}{4}$ ins. Collection: Dr Hubert Peeters, Bruges (photo: the artist).

28 *Soft Drainpipe – Blue (Cool) Version,* 1967. Canvas, metal, liquitex. $109\frac{1}{2}$ x $73\frac{7}{8}$ x 14 ins. Tate Gallery (photo: Eric Pollitzer).

29 *Giant Fagends – Scale I,* 1967. Canvas. polyurethane foam, hydrocal, liquitex. Thirteen pieces, from $19\frac{1}{2}$ to $41\frac{1}{2}$ x 11 ins. Painted wood base, $22\frac{3}{4}$ x 102 x $88\frac{5}{8}$ ins. The Kleiner Foundation, Beverly Hills (Courtesy Los Angeles County Museum of Art) (photo: Sidney Janis Gallery of New York).

30 British anti-smoking poster.

31 *Flues on Neighboring Roof,* 1967 from notebook page. Owned by the artist (photo: Robert Stillwell).

32 Flues on roof neighboring Oldenburg's 14th Street studio, New York (photo: the author).

33 *Lipstick on Caterpillar Tracks (for Yale University),* 1969. Cor-ten steel, wood (epoxied), painted with enamel. 24 x 21 x 17 feet (photo: Shunk-Kender).

34 *Giant Icebag,* 1969–70. Vinyl, gears, hydraulics, blowers. $16\frac{1}{2}$ x 18 feet. Cap: wood, silver lacquer, 8 feet in diameter. Courtesy Gemini G. E. L., Los Angeles (photo: Malcolm Lubliner)

35 *Plug = Legs = Shoestring Potatoes,* 1966, notebook page. Pen and pencil. 11 x $8\frac{1}{2}$ ins. Collection: the artist (photo: Robert Stillwell).

36 *System of Iconography – Double 'Ray Guns' – Drainpipe, et al.,* 1969. Pencil. $8\frac{1}{2}$ x 11 ins. Collection: the artist (photo: Robert Stillwell).

37 *Giant Soft Drum Set,* 1967. Vinyl, canvas, foam rubber, painted wood, metal; wood base covered with formica; chrome metal railing. 125 pieces. 84 x 72 x 48 ins. overall. Collection: John and Kimiko Powers, Aspen, Colorado (photo: Cleveland Museum of Art).

38 *Brancusi's Double Ray Gun, etc.,* 1966, notebook page. Pen and ink. 11 x $8\frac{1}{2}$ ins. Collection; the artist. (photo: Robert Stillwell).

39 *Study of a Soft Fireplug, Inverted,* 1969. Pencil. 29 x 23 ins. Collection John and Kimiko Powers, Aspen, Colorado. (photo: Jonas Dovydenas).

40 *Shoestring Potatoes Spilling from a Bag,* 1965–6. Canvas, kapok, glue, liquitex. 108 x 46 x 42 ins. Walker Art Center, Minneapolis. (photo: Eric Pollitzer).

41 *Rex Airport, Neubern, c.* 1939. Crayon and pencil. $8\frac{1}{2}$ x 11 ins. Collection: the artist. (photo: Robert Stillwell).

42 *Neubern vs. Nobbeberg 1430–1939,* 1939. Crayon and pencil. $13\frac{1}{4}$ x $8\frac{1}{2}$ ins. Collection: the artist (photo: Robert Stillwell).